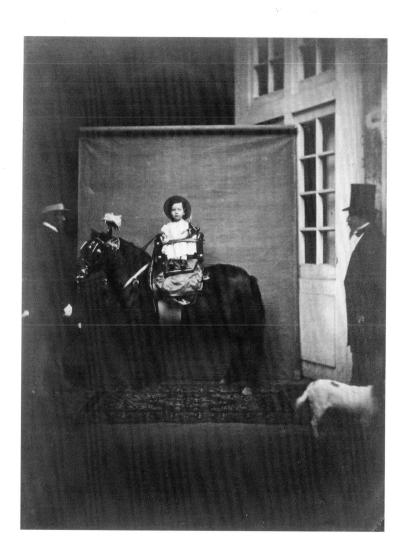

LOOKING AT PHOTOGRAPHS

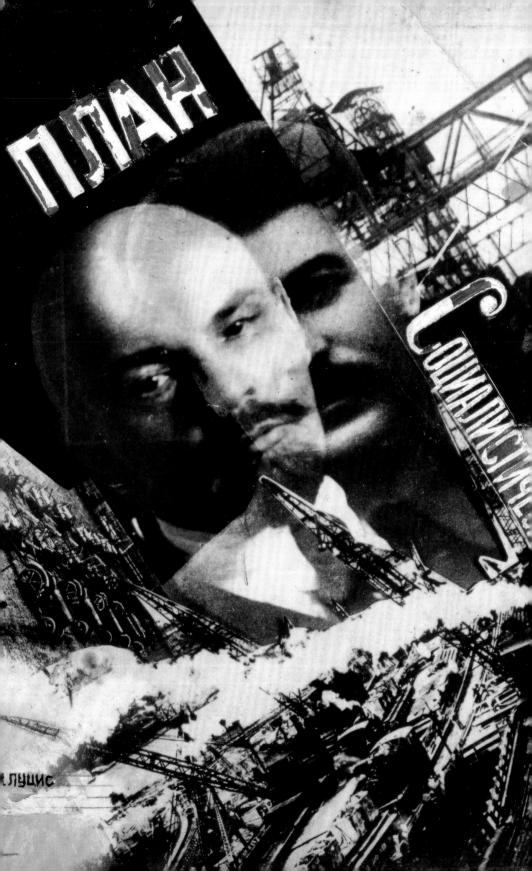

PHOTOGRAPHS

A GUIDE TO TECHNICAL TERMS

REVISED EDITION

GORDON BALDWIN AND MARTIN JÜRGENS

THE J. PAUL GETTY MUSEUM • LOS ANGELES

© 2009 J. Paul Getty Trust

First edition published 1991 Revised edition 2009

Published by the J. Paul Getty Museum

Getty Publications 1200 Getty Center Drive, Suite 500 Los Angeles, California 90049-1682 www.getty.edu/publications

Gregory M. Britton, *Publisher* Mark Greenberg, *Editor in Chief*

Library of Congress Cataloging-in-Publication Data

Baldwin, Gordon,

Looking at photographs: a guide to technical terms / Gordon Baldwin and Martin Jürgens. — 2nd ed.

p. cm.

Includes bibliographical references and index.

ISBN 978-0-89236-971-3 (pbk.)

1. Photography — Terminology. I. Jürgens, Martin C. II. Title.

TR9.B35 2009

770.1'4 — dc22

2008046566

Printed in China through Oceanic Graphic Printing, Inc.

The publishers would like to acknowledge that the title *Looking at Photographs* was first used by the Museum of Modern Art, New York, in 1974, for a book by John Szarkowski. Mr. Szarkowski's invaluable guide to the aesthetics of photography is wholly different from the present glossary of technical terms.

Cover artwork: David Hockney (British, b. 1937), Pearblossom Hwy., 11–18th April 1986 (Second Version) (detail). See p. 96.

p. i: Louis Pierson (French, 1818–1913), Napoleon III and the Prince Imperial, ca. 1859. Albumen print, 20.4 x 15.6 cm (8 1 /16 \times 6 1 /8 in.). JPGM, 84.XM.705.

p. ii: G. G. Klucis (Russian, 1895–ca. 1938), Project for a Poster of the Socialist Plan, 1920 (detail). See p. 18.

p. vi: Adam Bartos (American, b. 1953), Hither Hills State Park, Montauk, New York, 1991–94 (detail). See p. 16.

In the captions, the initials JPGM are used for the J. Paul Getty Museum. In the dimensions that accompany photographs, height precedes width.

Contents

Preface to the Revised Edition	vii
Glossary	I
Selected Bibliography	92
Index	93

Preface to the Revised Edition

The purpose of this book is to provide a series of concise explanations of the terms most frequently used by curators, collectors, and historians to deal with the phenomenon called *photography*. As it is intended for someone actually looking at photographs, the list of terms has been limited to those likely to appear on descriptive labels in exhibitions or in catalogue entries. First published in 1991, this book has now been revised and updated to include digital terminology.

From its origins at the end of the 1830s, photography has never ceased to evolve both aesthetically and technologically. For example, judging by their letters to the periodicals of the 1850s, individual photographers consistently modified both the chemical formulae and the physical manipulations required to produce negatives and prints. They also redesigned and altered their cameras and lenses. Early photographers introduced these modifications for a variety of reasons, but principally to improve the efficacy of the chemical reactions involved or to produce a variety of visual results that were governed by aesthetic choices. Today changes occurring in photographic materials and equipment are far more likely to be the work of commercial manufacturers. In all periods, however, change has been constant. For this reason the descriptions of processes that follow are somewhat generic. When trade names have been introduced, they have been given as examples rather than recommendations.

In the writing—and now the revising—of this book we have had the welcome advice of many friends and colleagues at the J. Paul Getty Museum, British Museum, and other institutions. We are grateful to Brett Abbott, Andrea P. A. Belloli, Robin Clark, Sheryl Conkelton, Christopher Date, Alan Donnithorne, Joan Dooley, Teresa Francis, Sarah Freeman, Andee Hales, Peggy Hanssen, Kurt Hauser, Karen Hellman, Graham Howe, Judith Keller, Hope Kingsley, Craig Klyver, Anne Lacoste, Dominique Loder, Brita Mack, Paul Martineau, Stacy Miyagawa, Julia Nelson-Gel, Debra Hess Norris, Arthur Ollman, Mark Osterman, Tania Passafiume, the late Charles Passela, Sandra Phillips, Ellen M. Rosenbery, Larry Schaaf, Karen Schmidt, Louise Stover, the late John Szarkowski, the late Jay Thompson, and Mike Ware. We are particularly indebted to Weston Naef for his encouragement, to John Harris and Frances Bowles for their nearly infinite patience, and to Jean Smeader for both patience and paleographic expertise.

Gustave Le Gray (French, 1820–1884), Brig on the Water, 1856. Albumen print, 32×40.8 cm ($12\% \times 16\%$ in.). JPGM, 84.XM.637.2.

Glossary

Note: Words printed in SMALL CAPITALS refer to other entries in the book. Synonymous terms appear in parentheses; related terms are separated by a slash mark.

ALBUMEN PRINT

The albumen print was invented in 1850 by Louis-Desiré Blanquart-Evrard (1802–1872), and it was the most prevalent type of print until the 1890s. Normally made from a COLLODION negative on glass, the process yielded a clearer image than the SALT PRINT process that preceded it in general use. An albumen print was made by floating a sheet of thin paper on a bath of egg white containing salt, which had been whisked, allowed to subside, and filtered. This procedure produced a smooth coating of albumen on the surface of the paper. Papers were often double-coated to increase their gloss. After drying, the albumenized paper was SENSITIZED by floating it on a bath of silver nitrate solution. The paper was again dried, but this time in the dark, since the salt in the albumen and the silver nitrate had combined to form LIGHT-SENSITIVE SILVER SALTS. For EXPOSURE, the paper was put into a wooden, hinged-back frame, in contact with a negative, usually collodion on glass but occasionally a paper negative (see CALOTYPE and WAXED PAPER NEGATIVE); it was then placed in the sun to produce a CONTACT PRINT by printing-out. The progress of the printing, which sometimes required only a few minutes but could take an hour or more, could be checked by carefully opening the back of the frame.

The resultant print, still unstable, was fixed by being immersed in a solution of sodium thiosulfate and then thoroughly washed to remove the fixer and prevent further chemical reactions. The print was then dried. After 1855, albumen prints were almost always toned with gold chloride to enrich their color and increase their permanence. The finished print ranges in color from reddish to purplish brown and is usually glossy, although some early photographers preferred to reduce surface sheen by diluting the albumen with water. If an albumen print has deteriorated, its highlights are yellowish and the image may have faded to a yellowish brown.

AMBROTYPE (COLLODION POSITIVE)

Ambrotypes (from the Greek ambrotos, meaning immortal), as they are called in America, were popularized by James Ambrose Cutting (1814–1867), who patented a specific variety of them. They are often confused with the earlier DAGUERREOTYPES but were made by an entirely different process, as their British name, COLLODION POSITIVES on GLASS, indicates. Both ambrotypes and daguerreotypes were similar in their size (small), in their packaging format (under glass in hinged cases), and in their superficial appearance (both having sharply defined images). Both were primarily used for portraiture and were unique images. In contrast to the daguerreotype, an ambrotype, however, always remains a POSITIVE image regardless of the

1

AMBROTYPE

Mathew Brady (American, 1822–1896), *Portrait of a Woman and Child*, 1851. Half-plate ambrotype with hand-coloring, 12.3 × 9.1 cm (4⁷/₈ × 3⁹/₁₆ in.). JPGM, 84.XP.447.10.

angle at which it is viewed, and its highlights are soft and pearly in tone rather than clear and crisp.

The procedure for producing an ambrotype was first published in 1851. An ambrotype is an underexposed and COLLODION NEGATIVE on glass, whitish in tone. When backed with a dark opaque coating (black lacquer, for example), the negative appears as a positive image. Ambrotypes can be presented with either the image side or the nonimage side of the glass plate facing the viewer. In the former case, the image is reversed, and where a highlight is juxtaposed to a black area, there can be a surprising discontinuity of surface caused by the dimensional difference between the image on the face of the glass plate and the black backing.

As ambrotypes were easier to tint and faster and cheaper to make and sell than daguerreotypes were, they rapidly replaced daguerreotypes in the late 1850s, only to be largely replaced in turn by TINTYPES and CARTES-DE-VISITE in the 1860s.

APERTURE See EXPOSURE.

ATTRIBUTION

An *attribution* is an authoritative statement that an unsigned photograph can be said confidently, but not definitively, to have been made by a specified photographer on the grounds of close stylistic affinity to signed works by that maker and/or other compelling circumstantial evidence.

AUTOCHROME

An *autochrome* is a colored transparency on Glass, similar, in principle, to a modern slide, ranging in size from less than 2 inches (5.1 cm) square to 15 by 18 inches (38.1 by 45.7 cm). It is meant to be viewed in a device that allows light to pass through it from the back or by being projected onto a surface. Deeply luminous in color if not faded, and with soft image outlines, each autochrome is a unique object. It is the most successful of a number of different so-called Screen plate processes.

Autochromes were the first really practicable photographs in color and were made by a process invented and patented in 1904 by Louis Lumière (1864–1948),

AUTOCHROME

Alfred Stieglitz (American, 1864–1946), Kitty Stieglitz, 1907. Autochrome, 14.2 × 9.8 cm (55/8 × 37/8 in.). JPGM, 85.XH.151.5. © Georgia O'Keeffe Museum. the younger of the two brothers who figured so prominently in the invention of the motion picture. The process consisted of coating a GLASS PLATE with sticky varnish, then with a very thin, pressed layer of minuscule grains of translucent potato starch. The grains had been previously divided into three equal lots, and each lot separately dyed red-orange, blue-violet, and green. Mixed together in random distribution, they formed a dense mosaic color filter on the plate. Over this layer of grains was added another coating of varnish and, last, a silver halide GELATIN EMULSION that was sensitive to the entire spectrum of light, that is, was panchromatic.

Plates thus coated, which were manufactured in large quantities between 1907 and about 1940 by the Lumière brothers' company, were exposed in a camera, glass-side forward, so that light entering the Lens would pass through the color mosaic filter before reaching the emulsion. (The starch grain mosaic served to filter the light so that the underlying bromide emulsion was selectively exposed by color.) The plates were then Developed and Washed.

The resulting NEGATIVES were then placed in a chemical bath in order to bleach out the negative impression. After exposure to white light, the plates were redeveloped, resulting in a POSITIVE image that was FIXED, washed a final time, and varnished for protection. The dyed starch particles that remained in alignment with the emulsion throughout processing render the black-and-white positive in color and give the image a grainy appearance that is unique in color photography.

BARYTA See FIBER-BASED PAPER.

BICHROMATE PROCESSES (DICHROMATE PROCESSES)

As with SILVER SALTS and IRON SALTS, chromium salts (most notably potassium and ammonium bichromate) have found use in photography and PHOTOMECHANICAL printing due to their LIGHT-SENSITIVITY. Upon EXPOSURE to light, *bichromates* are capable of hardening GELATIN and gum arabic; as a result, the exposed areas are rendered less absorptive and soluble in water.

The term *bichromate* is actually outdated chemical nomenclature and has been replaced by *dichromate*, but the old term is often found in the literature and is still in general use today. See also BROMOIL PRINT, CARBON PRINT, CARBON PRINT, COLLOTYPE, DYE TRANSFER PRINT, GUM BICHROMATE PRINT, PHOTOGLYPHIC ENGRAVING, PHOTOGRAVURE, PHOTOLITHOGRAPHY, PIGMENT PROCESSES, and WOODBURYTYPE.

BINDER

A *binder* is a substance that is used in photographic materials to hold the imaging material, such as silver or pigment, on the support. It is commonly a surface layer that gives a process its name: in Albumen Prints, for example, the binder is albumen. The most common photographic binder has been Gelatin, found in many different forms since the beginnings of photography, both for black-and-white and color photography. Starch (in Salt Prints) and Collodion were also popular binders. See also emulsion.

BLINDSTAMP (DRYSTAMP)

This kind of stamp is an identification mark embossed onto the MOUNT to which a photograph has been attached. Less frequently, the blindstamp appears on the photograph itself. The stamp's raised or depressed letters usually spell the name or the address of the photographer. As no ink is used, the stamp is less visible than a WET-STAMP. Blindstamps were commonly used during the nineteenth century and are sometimes employed in modern commercial portraiture. Blindstamps that identify a printing studio may also be found on the margins of INKJET PRINTS that have been printed in EDITIONS, particularly those on high-quality fine art paper.

BLINDSTAMP

Blindstamp on the mount of a photograph by Nadar (Gaspard-Félix Tournachon) (French, 1820–1910). Diam. 4.2 cm (1% in.). JPGM, 84.XM.436.485.

BROMOIL PRINT / OIL-PIGMENT PRINT

The bromoil process for making prints, which originated in England in 1907 and remained popular into the 1930s, was an outgrowth of earlier oil-pigment processes and was related to the GUM BICHROMATE process. It depended on the underlying principle of lithography, namely, that oil and water repel each other.

The process for producing a *bromoil print* began with a GELATIN SILVER BROMIDE PRINT, usually an ENLARGEMENT from a smaller negative. This print was bleached in a solution of copper sulfate, potassium bromide, and potassium bichromate and then fixed. The visible image had disappeared and the gelatin had been hardened by the potassium bichromate in proportion to the amount of silver that made up the original image. The sheet, called a *matrix*, was soaked so that the gelatin would absorb water and was left damp. Lithographic ink or another greasy ink was then carefully and repeatedly dabbed onto the surface of the matrix with a special brush or gently applied with a rubber roller called a *brayer*. Where the gelatin had absorbed water (in the highlights and, to a lesser degree, in the midtones), it repelled the oilbased ink. Repeated applications of ink gradually built up the matrix to whatever density was desired. The print thus created was either slowly dried or used once in a press, while still wet, as a kind of printing plate to transfer the inked image to another surface. It is the combination of the original *brom*ide print and the *oil* pigment ink that gives the bromoil print its name.

The chosen color of the ink determined the color of the final bromoil print. (Full color was also possible by the use of three separate bromide prints for bromoil

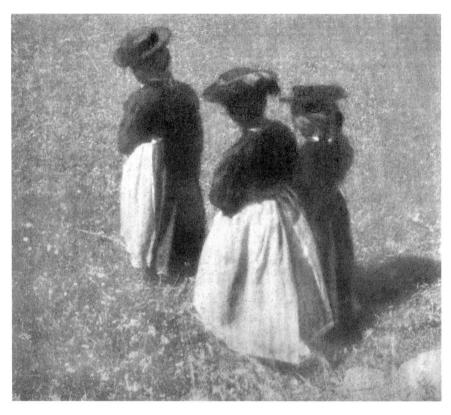

BROMOIL PRINT / OIL-PIGMENT PRINT

Heinrich Kühn (Austrian, b. Germany, 1866–1944), Women from Pustertal (Pustertalerinnen), ca. 1913/14.

Bromoil transfer print, 21.9 × 25.1 cm (8 % × 9 % in.), 1PGM, 84.XM.829.13.

transfer, made from three negatives, each exposed through a different color filter, and three successive applications of primary colors.) The range of tones of a bromoil print is broad, and its surface shows a slight relief unless it is a transfer print. Bromoil prints do not have high detail resolution, but selective brushwork permitted a wide latitude of manipulation of the image.

BURNING-IN

Burning-in is a technique by which a photographer can darken the tones of a specific area of a photographic print. It is used to alter highlight areas that show too little detail, that is, are too light in tone, or for dark areas that are too light. The photographer usually decides to employ burning-in after examining the negative, a CONTACT SHEET, or, more likely, an enlarged trial print from the negative. The technique is most often used during enlargement and consists of overexposing selected areas of the photographic paper during an additional exposure by interposing a piece of cardboard or the like, with a hole cut out in its center, between the beam of light coming through the negative via the enlarger LENS and the photographic paper.

The unshaded areas thereby receiving additional exposure will darken to a greater degree during development. To avoid creating a sharp outline around the burnt-in area, the photographer continuously moves the cardboard back and forth during exposure. Depending on the shape and size of the area to be darkened, holes or silhouettes of various dimensions can be cut in the cardboard. The photographer can also use cupped hands or fingers for greater control. For burning-in while CONTACT PRINTING, the cardboard or the hand is interposed between the light source and the negative. For a related technique, see DODGING.

CABINET CARD

A *cabinet card*, larger in scale and later in date than a CARTE-DE-VISITE, was a stiff piece of thick cardstock, about 6½ by 4½ inches (15.9 by 10.8 cm), bearing on one side a photograph of somewhat smaller dimensions. Initially the photograph was nearly always an ALBUMEN PRINT (but later was a GELATIN SILVER, COLLODION, PLATINUM, or CARBON PRINT) and was most often a bust-length portrait made in a studio, although views were also popular. The balance of the space on the face of the card at the top or bottom was usually printed or embossed with the photographer's name or insignia and occasionally with the name of the sitter. Often the back also bore the photographer's imprint. Introduced in the 1860s, cabinet cards gradually superseded the flimsier and smaller cartes-de-visite in the public's favor. Their popularity waned in the 1890s, particularly after the introduction of scenic view postcards and enlarged studio portraits.

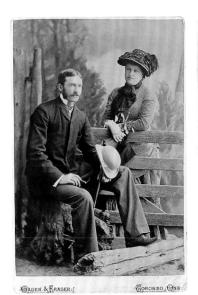

CABINET CARD

Gagen and Fraser (Robert Ford Gagen, Canadian, b. England, 1847–1926 and John Arthur Fraser, English, active North America, 1838–1898), *Portrait of a Canadian Couple*, ca. 1885. Albumen print cabinet card, recto and verso, 16.5 × 10.7 cm (6½ × 4¼ in.). JPGM, 84.XD.879.149.

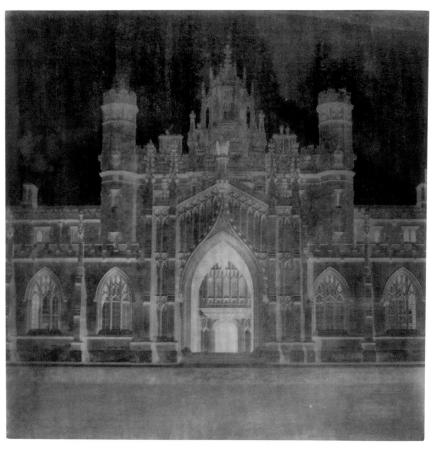

CALOTYPE (TALBOTYPE)

William Henry Fox Talbot (British, 1800–1877), New Court, St. John's College, Cambridge, ca. 1845.

Waxed calotype negative, 16.8 × 16.9 cm (65/8 × 65/8 in.). JPGM, 84.XM.1002.5.

CALOTYPE (TALBOTYPE)

William Henry Fox Talbot (1800–1877) invented the calotype process for making paper negatives in 1840 and patented it in 1841. As a process that involved both a NEGATIVE and a POSITIVE, it was the direct ancestor of modern photography. Unlike the DAGUERREOTYPE, which was a unique object, the calotype involved the creation of a negative that could be used for making multiple prints. These were usually SALT PRINTS. The *calotype* was a significant advance over Talbot's earlier PHOTOGENIC DRAWING process, as he used chemicals that were more LIGHT-SENSITIVE and the negative image was completed by DEVELOPMENT rather than PRINTING-OUT. The process, with various modifications, was popular from 1841 until the early 1850s, when it was superseded by the WET COLLODION on GLASS process. It enjoyed a revival about 1900 by the Pictorialist photographers, who valued the light-diffusing effect created by the fiber mesh of the paper support.

A calotype was made by brushing a silver nitrate solution onto one side of a sheet of high-quality writing paper and drying it. Then, by candlelight, the sheet was floated on a potassium iodide solution, producing slightly light-sensitive silver iodide. The sheet was dried again, this time in the dark. Shortly before EXPOSURE in a camera, the paper was, in weak light, again swabbed with silver nitrate, this time mixed with acetic and gallic acids (Talbot's so-called exciting solution), thus producing full light sensitivity. This sensitized sheet could be used damp in the camera, where an exposure of between ten seconds and ten minutes was necessary, depending on the weather, time of day and year, choice of chemicals employed, and subject. At this point the image was not visible but LATENT in the paper. To develop the image, the sheet was again dipped in a bath of silver nitrate and acetic and gallic acids. To stabilize the negative image, now wholly visible on the paper, Talbot WASHED the paper in water, then bathed it with a solution of potassium bromide. He then washed the paper in water again and dried it. Soon after his announcement of this method, Talbot, at the suggestion of Sir John Herschel (1792–1871), amended its final steps by FIXING the image with hyposulfite of soda ("hypo"; see FIXING), a chemical still in use but now correctly known as sodium thiosulfate.

The negative thus produced could then be used for the printing of positive prints. Its transparency could be improved by waxing. (A variant on this process is the WAXED PAPER NEGATIVE.) As the image was embedded within the paper (rather than carried on a completely transparent support such as glass), the paper fibers tended to print through to the printed image, causing a relative lack of clarity in the details and a characteristic overall subtle mottling of tones.

The word *calotype* has frequently also been used to refer to the SALT PRINTS made from calotype negatives, as well as the negatives themselves. Talbot used it only for negatives, and it seems simpler to reserve the word for the negative alone or to differentiate between a *calotype negative* and a *calotype positive*. Before 1850, the negatives were admired as objects in their own right, and negatives of that period are increasingly exhibited today. Talbot coined the word *calotype* from the Greek *kalos*, meaning beautiful, and the Latin *typus*, meaning image.

CAMERA

The nearly universal means for making a photograph is the *camera*, which basically consists of a lightproof compartment with, on one side, a LENS that can be opened and closed, usually by means of a SHUTTER, and through which the subject can be focused, and, on the other side, a flat, LIGHT-SENSITIVE material, whether FILM, GLASS PLATE, or charge-coupled device (see DIGITAL IMAGING), on which the image is received. Cameras have undergone nearly infinite permutations, from the tiny wooden boxes built and used in the mid-1830s by William Henry Fox Talbot (1800–1877), and which he referred to as mouse-traps, to the electronic marvels of the present. The name comes from the Latin for room, which a camera remotely resembles.

CAMERA LUCIDA

Patented and named in 1806 by William Hyde Wollaston (1766–1828), the *camera lucida* (Latin, meaning lighted room) was an apparatus to aid a draftsman in rendering a view. It consisted of a prism with three or four sides atop a vertical rod, with a clamp at the bottom to mount it to a drafting board or pad. The draftsman directed the prism's vertical side toward the desired view and looked down with one eye, through *and* past the prism's horizontal edge, to the paper below. To the eye, the view reflected through the prism seemed to merge with the paper surface below, so that the view appeared to be *on* the paper. The draftsman could then trace this image. Camera lucidas were awkward to use, and it was William Henry Fox Talbot's dissatisfaction with this tool, he said, that led him to invent the CALOTYPE process that evolved into modern photography. Although tricky to master, a camera lucida was more easily portable than its predecessor, the CAMERA OBSCURA.

CAMERA LUCIDA

Cornelius Varley
(British, 1781–1873),
Artist Sketching with
a Wollaston-Style
Camera Lucida (and
detail of eye-piece of
a camera lucida),
ca. 1830. Engraving.
Gernsheim Collection,
Harry Ransom
Humanities Research
Center, The University
of Texas at Austin.

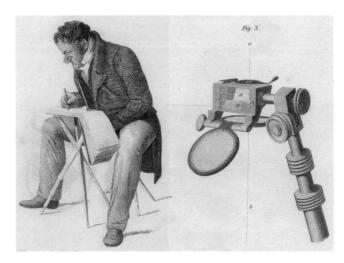

CAMERA OBSCURA

Georg Brander (German, 1713–1783), *Table Camera Obscura*, 1769, showing cross section with mirror. Engraving, 12 × 16 cm (4³/₄ × 6⁵/₁₆ in.). Gernsheim Collection, Harry Ransom Humanities Research Center, The University of Texas at Austin.

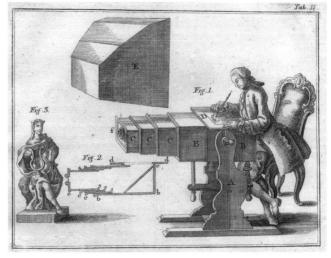

CAMERA OBSCURA

From the Latin, meaning dark chamber, the *camera obscura* was an ancestor of the modern camera. The principle that light rays travel in straight lines has been known since antiquity. As early as the ninth century it was observed that, when light rays reflected from a bright object enter a small hole in a darkened room, they produce an inverted image of that object on the opposite wall. By the seventeenth century this observation had led to the creation of a portable camera obscura as an aid for drawing, a use Giovanni Battista Della Porta (ca. 1542–1597) had first suggested a century earlier.

A simple form of this draftsman's apparatus consisted of an oblong closed box fitted at one end with a LENS that could be adjusted to focus on a subject. Inside the box, at the other end, a mirror, attached at a forty-five-degree angle, projected the image up onto a GROUND GLASS screen that had been set into the top of the box. It was on this ground glass screen that the image could then be traced on thin paper by the draftsman. (The mirror also served to vertically reverse the image, which had been inverted as it passed through the lens. The image traced by the draftsman was, however, not a "true" image as it was still laterally reversed.) In this way, a view in three dimensions was converted to one in two dimensions, facilitating the draftsman's task.

CARBON PRINT

Although patented in 1855 by Alphonse-Louis Poitevin (1819–1882) and improved in 1858 by John Pouncy (ca. 1808–1894), *carbon prints* became fully practicable only in 1864, with the patented process and printing papers of Joseph Wilson Swan (1828–1914). The primary importance of a carbon print is its relative permanence (its resistance to fading), as it contains neither silver nor chemical impurities that can DETERIORATE. The process's underlying principle is the fact that GELATIN to which potassium BICHROMATE has been added becomes insoluble when EXPOSED to light, in proportion to the amount of light received.

Basically, the process worked as follows. A sheet of lightweight paper, often referred to as a tissue, was coated with a pigmented gelatin (the pigment often being the carbon black that gives the process its name). The tissue was rendered LIGHT-SENSITIVE in a bath of potassium bichromate, then dried, and then exposed to light while in CONTACT with a negative. Those parts of the gelatin that were exposed to light through the negative hardened proportionately to their exposure. In order to reveal the image, the face of the exposed carbon tissue was squeezed in contact with a second sheet of paper already coated with an insoluble gelatin layer, thus forming a sort of gelatin sandwich; this sandwich was then soaked in warm water. The original tissue floated free or was peeled away, and the unhardened gelatin was WASHED away, leaving only the image attached to the second sheet. (This transfer was necessary as the originally exposed tissue had a topmost, impermeable film of hardened gelatin, so that when soaked, the underlying soft layer of gelatin, in contact with the paper itself, would have caused the whole of the gelatin layer to lift up from its support.)

The sheet was then immersed in water containing alum, which further hardened the remaining gelatin and removed any yellowish bichromate stains. Because of the transfer to a second sheet of paper, the finished image was reversed (as it was in early DAGUERREOTYPES). This effect could be counteracted either by reversing the negative at the outset or by a second reversing transfer at the end. In some instances, however, photographers were content to leave the image reversed.

Popular between 1870 and 1910, carbon prints exhibit dense glossy darks, either black or a deep rich brown in color. A wide variety of other colors was possible by using various pigments. The prints have slight relief contours, thickest in the darkest areas, where more pigmented gelatin remains. Carbon prints are occasionally made today, sometimes by means of the related, patented Fresson process.

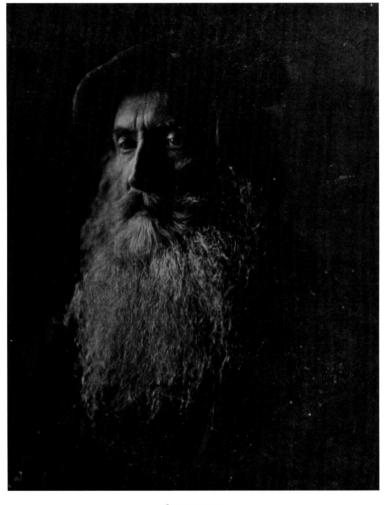

CARBON PRINT

Julia Margaret Cameron (British, 1815–1879), Henry Taylor as Rembrandt, 1865.

Carbon print, 25.3 \times 20.1 cm (10 \times 7% in.). JPGM, 85.XM.129.1.

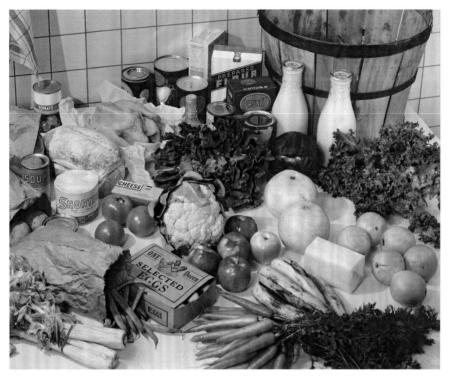

CARBRO PRINT

Paul Outerbridge (American, 1896–1958), *Food Display*, 1937. Tricolor carbro print, 36.2 × 44.3 cm (141/4 × 177/6 in.). JPGM, 87.XM.66.4. © G. Ray Hawkins Gallery, Beverly Hills, California.

CARBRO PRINT

The *carbro print* process of about 1919 is an outgrowth of the earlier CARBON PRINT process of the 1860s that led, via the now-obscure ozotype and ozobrome processes, to the color carbro process. A monochrome carbro print begins with a finished GELATIN SILVER BROMIDE print, which is a print made on paper bearing a highly LIGHT-SENSITIVE silver bromide EMULSION. This print, when wet, is pressed together with a sensitized carbro tissue. The tissue is a thin paper coated with pigmented GELATIN that has first been sensitized by immersion in a solution of potassium BICHROMATE and then placed into a bath containing bleaching agents. Through chemical action, the gelatin of the carbro tissue hardens in proportion to the selective bleaching out of the silver of the bromide print during the period the two papers are in contact. The print and the tissue are then separated, and further processing is the same as that of the carbon print: the tissue is placed facedown on a sheet of transfer paper for about twenty minutes. The tissue and transfer paper are then separated in warm water, leaving the gelatin layer attached to the transfer paper. The paper is then bathed until the gelatin that has not hardened and has remained water-soluble is washed away, leaving only the partially hardened gelatin image. The print is further hardened in an alum bath; then it is dried. As it is silverfree, the monochrome image thus produced is not susceptible to fading. The original bromide print, now bleached, can be redeveloped and used to make as many as five additional carbro prints.

Tricolor carbro prints are made with three bromide prints of one subject. The NEGATIVES for these prints are made by successively photographing the subject or a color image of the subject through a red, a green, and a blue filter. From these *separation negatives* the bromide prints are made. Each is then placed in contact with a bichromated gelatin tissue that is pigmented with the complementary color of the filter used for the negative (cyan pigment for the red filter, magenta for the green, and yellow for the blue). The process continues as described above, and the resultant three transfers, each a different color, are stacked together in careful alignment, that is, in registration, to produce a single full-color image. Like a black-and-white carbro print, the resulting color image is very resistant to fading. The name *carbro* comes from *carb* and *bro* mide. The process was mainly used from the 1930s onward, particularly for images used in advertisements and fashion photography, until the DYE TRANSFER process supplanted it in the 1950s.

CARD PHOTOGRAPH

The term *card photograph* applies to any of the standard-sized nineteenth-century commercially formatted photographs mounted to cards of various weights. Most successful were the small CARTE-DE-VISITE and the midsized CABINET CARD, but card photographs also included, in ascending order of size, the Trilby (about 2 by 2¾ inches [5.1 by 7 cm]), Victoria, Promenade, Boudoir, and Imperial (about 7 by 10 inches [17.8 by 25.4 cm]).

CARTE-DE-VISITE

A carte-de-visite is a stiff piece of cardstock measuring about 4½ by 2 inches (II.4 by 6.4 cm), the size of a formal visiting card of the 1850s (hence the name), with an attached photograph of nearly the same size. Patented in 1854 by A. A.-E. Disdéri (1819–1889) and popularized by him in the following decade, cartes normally bore carefully posed full-length studio portraits, often of celebrities. They were nearly always Albumen prints from collodion on glass negatives. Cartes-de-visite were made by the millions worldwide during the 1860s and were often collected in albums for home perusal. When they were not portraits, their subjects were often scenic views, tourist attractions, local inhabitants, or reproductions of works of art. The backs normally were printed with the photographer's name and address and, sometimes, insignia. They were gradually replaced in the public's esteem by the Cabinet card during the late 1870s.

CASED PHOTOGRAPH

A *cased photograph,* nearly always a daguerreotype or ambrotype, is a photograph that has been secured, usually by its maker, inside a shallow hinged case for its safe-keeping or display. Cases were widely available commercially from the early 1840s to

CARTE-DE-VISITEWilliam and Daniel Downey (British, active ca. 1860—early 1900s), *Queen Victoria*, ca. 1880. Albumen print carte-de-visite, recto and verso, 10.3 × 6.3 cm

(4½16 × 2½ in.). JPGM, 84.XD.737.2.71.

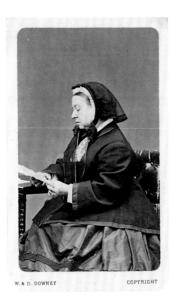

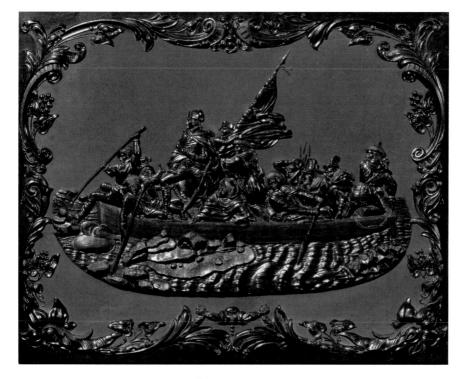

PHOTOGRAPH CASE

Thermoplastic whole-plate daguerreotype case manufactured by Littlefield, Parsons and Company, 1858. Lid with image molded from a die engraving by Frederick B. Smith and Herman Hartmann adapted from Emanuel Leutze's painting *Washington Crossing the Delaware*, 18.3 × 23.4 cm (73/16 × 91/4 in.). JPGM, 84.XT.1568.2.

give additional protection to daguerreotypes, which as a matter of course had glass coverings over their image surfaces.

The three principal kinds of cases were thin, embossed, leather-covered, lidded wooden boxes; papier-mâché cases; and molded and lidded boxes made of thermoplastic (pressed, pigmented sawdust and shellac), with embossed decorative elements, usually called union cases. All three kinds were only slightly larger than the daguerreotypes they contained. They were usually lined with velvet or silk, which sometimes was imprinted with the photographer's name. The daguerreotype, cover glass, and brass mat were held together with a paper seal and enclosed by a thin brass outer frame, called a *preserver*. This unit was inserted into the case.

CELLULOSE ACETATE / CELLULOSE NITRATE See FILM.

CHROMOGENIC PRINT

Chromogenic EMULSIONS were introduced to the market in 1935 and have been used in many variants since then for color NEGATIVES, TRANSPARENCIES ON FILM, and PRINTS. Since their conception, these materials have been those most commonly used in both amateur and professional color photography. A *chromogenic print* is a color print made from a negative, in which the emulsion has three layers, each of which contains SILVER SALTS that have been SENSITIZED to one of the three primary colors of light: red, green, and blue. Each layer records a different part of the color makeup of the image (the red-sensitive layer "remembers" red, and so on). During EXPOSURE

CHROMOGENIC PRINT

Adam Bartos (American, b. 1953), *Hither Hills State Park, Montauk, New York,* 1991–94. Chromogenic print, 50.8 × 76.2 cm (20 × 30 in.). Gift of Nancy and Bruce Berman. JPGM, 98.XM.199.10. © Adam Bartos.

from a negative, a LATENT IMAGE is formed in each layer. After initial DEVELOPMENT of the silver images, further processing follows, in which embedded chemical compounds (dye couplers) react with the products of the silver development to form yellow, magenta, and cyan dyes in the appropriate emulsion layers (the red-sensitive layer forms cyan dyes, the green layer, magenta, and the blue layer, yellow). The remaining silver is then bleached and removed in the fixing process. Finally, the print is WASHED. When seen against the white base of the print stock, the layers appear as a single image in full color. Early prints were produced on fiber-based paper, but modern prints are mainly found on RESIN-COATED PAPER supports. Chromogenic prints are also called *color-coupler prints* or (often inaccurately) *C-prints*.

Chromogenic (from the Greek, meaning color forming) prints are variously resistant to deterioration, such as fading in light or staining from residual substances in the emulsion. Prints made before the mid-1990s may be regarded as generally unstable; later prints can be as stable as DYE DESTRUCTION OF DYE TRANSFER prints are if they have been processed properly and are stored in cool, dry, and dark conditions.

CLICHÉ VERRE

The French term *cliché verre* (meaning glass negative) denotes a particular use of GLASS as a NEGATIVE for a drawing. The GLASS PLATE can be prepared in either of two ways. The more common method is to cover the plate with an opaque ground, such as paint or soot from smoke, and then to draw with a pointed instrument on

CLICHÉ VERRE

Man Ray (American, 1890–1976), Figure in Harem Pants, 1917.
Gelatin silver cliché verre, 17.3 × 12.2 cm (613/16 × 413/16 in.).
JPGM, 84.XM.1000.107.
© Man Ray Trust ARS-ADAGP.

it, scratching through to the glass, much like preparing an etching plate for biting in acid. The plate is then used as a negative and CONTACT PRINTED OF ENLARGED ONTO a sheet of LIGHT-SENSITIVE paper. The print thus produced is a design of dark lines on a white background. The alternate method is to draw with paint or another medium on uncoated glass. This, when used as a negative, produces a print with white lines on a dark ground. William Henry Fox Talbot (1800–1877) employed this process as early as 1835, and it continues to be used occasionally.

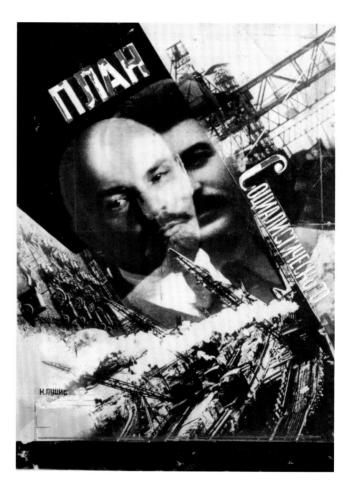

COLLAGE / MONTAGE
G. G. Klucis (Russian, 1895–ca. 1938), Project for a Poster of the Socialist Plan, 1920. Gelatin silver photomontage with applied paint, II.4 × 8.3 cm (4½ × 3½4 in.).

JPGM, 84.XP.458.17.

COLLAGE / MONTAGE

Collage (from the French coller, to glue) is the combination on a common support of diverse fragments of various materials. These can be photographic or not, with or without specific image content. There is normally no attempt to conceal the edges of the parts, which may be roughly torn or smoothly cut, and there may be considerable handwork in pencil, pen, or brush on the surface. The artistic result relies in part on juxtaposition and texture and often tends to the abstract.

Montage or photomontage (from the French monter, to mount) is the combination of diverse photographic images to produce a new work. The combination is often achieved by rephotographing the mounted elements or by multiple DARK-ROOM EXPOSURES. In the finished work, the actual physical edges become inconspicuous. The artistic result often tends to the surreal rather than the abstract.

Both collage and photomontage originated shortly before 1920, and the two are not always differentiated.

COLLODION / WET COLLODION PROCESS / DRY COLLODION PROCESS / COLLODION PRINTING-OUT PAPER

The wet collodion process was published, in 1851, by Frederick Scott Archer (1813–1857). It was prevalent from 1855 to about 1881, gradually displacing both the DAGUERREOTYPE and CALOTYPE processes. Wet collodion NEGATIVES on GLASS were valued because the transparency of the glass allowed for a high resolution of detail in the highlights and shadows of the resultant prints and because exposure times were shorter than were those for the daguerreotype or calotype, ranging from a few

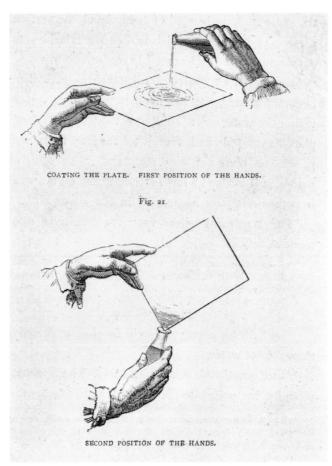

COLLODION / WET COLLODION PROCESS

Coating a glass plate and draining the excess collodion. Woodcut from Gaston Tissandier's *A History and Handbook* of Photography (New York, 1877). seconds to a few minutes, depending on the amount of light available. Collodion negatives were usually used to produce ALBUMEN PRINTS, although SALT PRINTS were also sometimes made from them during the 1850s and early 1860s. The collodion negative process is closely related to the AMBROTYPE and TINTYPE processes.

A commercial product, collodion (chemically a CELLULOSE NITRATE) was made from gun cotton, which was ordinary cotton that had been soaked in nitric and sulfuric acid and then dried. The gun cotton was dissolved in a mixture of alcohol and ether to which potassium iodide had been added and, in later years, bromide salts as well. The resultant collodion was a syrupy mixture that was poured, with one hand, from a beaker onto a perfectly cleaned GLASS PLATE, which was continuously and steadily tilted with the other hand, to quickly produce an even coating. (Since the prints were made by CONTACT PRINTING from the negative, the plate was of whatever size the finished print was to be.) When the collodion had set but the solvents had not completely evaporated (a matter of some seconds), the plate was sensitized by bathing it in a solution of silver nitrate, which combined with the potassium iodide in the collodion to produce LIGHT-SENSITIVE silver iodide.

The plate in its holder was then placed in a camera for exposure while still "damp"—hence the name of the process. After exposure, the plate was immediately DEVELOPED in a solution of pyrogallic and acetic acids; a later refinement of the process used ferrous sulfate as a developer. The plate was then thoroughly WASHED in water, FIXED with a solution of sodium thiosulfate, washed again, and dried. With the addition of a protective coat of varnish, the negative was now ready to be used to make prints. As some of these steps required darkness, photographers had to take dark tents or wagons as well as chemicals and glass plates into the field with them. That this complicated process was often used in remote places by nineteenth-century photographers is testimony to their diligence and dedication to their craft.

The *dry collodion process*, of which several types were developed between the mid-1850s and the mid-1860s, was a variant of the wet collodion process that allowed for the preparation of the plates in advance. These processes, also called *preserved collodion*, basically consisted of an additional, surface coating of the sensitized plate with an ingredient that kept the collodion slightly moist and thereby extended the time the plate remained usable; albumen, honey, gelatin, resin, raspberry syrup, and beer were among the substances employed. Collodion plates that were actually dry were created by immersing the collodion in tannic acid. Inconsistent results and exposures up to six times as long as those required for wet collodion meant that dry collodion plates never became widely popular.

Collodion PRINTING-OUT PAPERS, which had a silver chloride EMULSION, were popular from the 1880s until the early 1920s. They are most commonly encountered as glossy papers with a thick BARYTA coating, TONED with gold chloride, or as matte collodion papers that were usually toned with platinum.

COLLODION POSITIVE See AMBROTYPE.

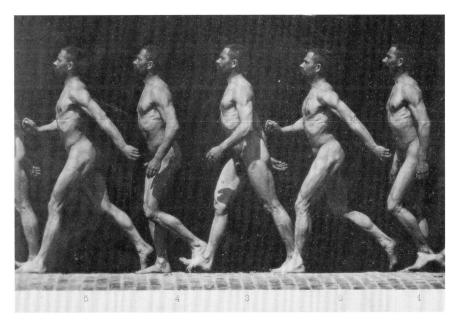

COLLOTYPE

Étienne-Jules Marey (French, 1830–1904), La marche, detail of plate 6 from Études de physiologie artistique (Paris, 1893). Collotype from a negative of ca. 1890, 11.3 × 17.6 cm (4%16 in.). JPGM, 84.XP.960.63.

COLLOTYPE

The *collotype* (from the Greek *kollo*, meaning glue) is a kind of PHOTOLITHOGRAPH in which glass replaces stone as the printing surface. In its gradual evolution from the work of Alphonse-Louis Poitevin (1819–1882) in the 1850s, the collotype has had a variety of names given to it by its proponents, among them the Albertype, Lichtdruck, phototype or phototypie, heliotype, and artotype. It is still in occasional use.

The collotype is a Photomechanically produced printed image, which can be of very high quality, made from a photographic image. Its production calls for a GLASS PLATE to be coated with a base layer of hardened GELATIN and a second layer of gelatin rendered sensitive to light by the addition of potassium or ammonium bichromate. The coated plate is then dried in a darkened oven at a precisely controlled low temperature for a specific duration, causing the gelatin to swell and buckle, producing a very finely veined pattern of valleys and bumps, called reticulation. The plate is then exposed to light (that is, contact printed) under a negative. In proportion to the amount of light received, the bichromated gelatin hardens. When the exposed plate is thoroughly washed in water, excess bichromate is removed. The resulting surface consists of areas of hardened and unhardened gelatin that vary in their capacity to absorb water.

Next, the plate is treated with a glycerin solution that promotes further absorption of water by the bumps that have remained unhardened. Then the plate is dampened and carefully rolled with ink. As in a lithographic process, the greasy ink

is repulsed from the water-swollen bumps but adheres along the lines of reticulation. The inked plate is then printed on paper, producing a finely detailed image with considerable subtlety of tone in the grays and the appearance of having continuous tone. The pattern of reticulation is visible only under high magnification; for this reason, a finished collotype, particularly if varnished, may be difficult to distinguish from a true photograph.

COLOR-COUPLER PRINT See CHROMOGENIC PRINT.

COLOR LASER PRINT See ELECTROPHOTOGRAPHIC PRINT.

COMBINATION PRINT

The combining of two or more NEGATIVES into a single print during the printing process results in a *combination print*. Its normal means of production begins with masking part of a negative when EXPOSING the printing paper under it and then re-exposing that paper under another partially masked negative, this time with the part of the print covered that had initially been exposed. Careful alignment, called *registration*, is necessary to produce a single, seamless image. The technique was used principally for landscapes, especially during the 1850s, when the oversensitivity of

COMBINATION PRINT

Henry Peach Robinson (British, 1830–1901), When the Day's Work Is Done, 1877. Albumen print from six negatives, 56.2×74.1 cm ($22\frac{1}{8} \times 29\frac{1}{8}$ in.). JPGM, 84.XM.898.

COLLODION negatives to blue light made it difficult to obtain a single negative that rendered both sky and landscape. Combination prints were also used in portraiture to place the sitter in a setting different from the one in which the photograph was actually made.

Another means of accomplishing a somewhat similar end was to print two negatives together simultaneously. From a specially prepared negative, the appearance of falling snow could thus be added to an image taken in midsummer, for example. A combination print is not to be confused with a DOUBLE EXPOSURE.

CONTACT PRINT / CONTACT SHEET

A *contact print* is made by exposure through a negative or, far less often, a positive, that has been placed directly onto photographic paper. The resulting image is necessarily of the same dimensions as the negative. Nineteenth-century prints on printing-out paper and all prints made by the Iron salt and Bichromate processes involve contact printing; most modern prints on Developing-out paper are enlargements. A *contact sheet* is made by exposing a set of film strips that have been laid down in rows and pressed into direct contact with photographic paper by means of a sheet of glass.

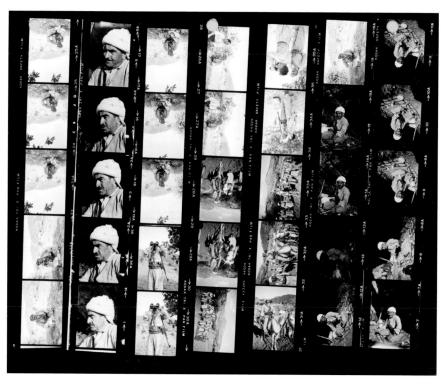

CONTACT SHEET

William Carter (American, b. 1934), *Iraq (Kurdistan)*, 1965. Gelatin silver 35mm contact sheet, 27.8 × 21.7 cm (10¹⁵/16 × 8⁹/16 in.). Gift of the artist. JPGM, 2007.48.51. © William Carter.

CRACKELURE OR CRACKLE (CRAQUELURE)

These terms (two English, the third, French) refer to a network of tiny cracks on a surface caused by the shrinkage of a covering layer from its support. In photography, they are used to describe the Deteriorated surfaces of some Albumen Prints, Carbon Prints, Gelatin Silver Prints, and Collodion negatives.

CROPPING (TRIMMING)

Cropping is the alteration of what appears in the negative of a photograph in order to change the proportions or dimensions of a print made from that negative. Often employed to edit out peripheral detail, cropping can be accomplished by physically cutting the edges of a print or by blocking the edges of the negative in the ENLARGING or printing processes. Unless another uncropped print or the negative itself is known, cropping is undetectable, although it can sometimes be deduced from a print's unusual proportions.

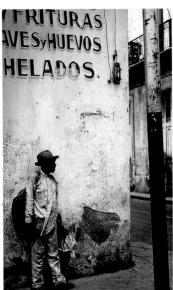

CROPPING (TRIMMING)

Walker Evans (American, 1903–1975), *Boy at Havana Corner*, 1933.

Gelatin silver print, 20 × 15.2 cm (7⁷/8 × 6 in.). JPGM, 84.XM.956.262.*Havana Corner*, 1933.

Gelatin silver print, 19.6 × 12.3 cm (7³/4 × 4⁷/8 in.). JPGM, 84.XM.956.168.

CYANOTYPE

The *cyanotype* process for making prints was invented in 1842 by Sir John Herschel (1792–1891) and derived from his recognition of the LIGHT-SENSITIVITY of IRON SALTS. A sheet of paper was brushed with a solution of ferric ammonium citrate and potassium ferricyanide and dried in the dark. The object to be reproduced, be it a drawing, negative, or plant specimen, was then placed in CONTACT with the sensitized sheet, and the image was PRINTED-OUT in daylight. After about a

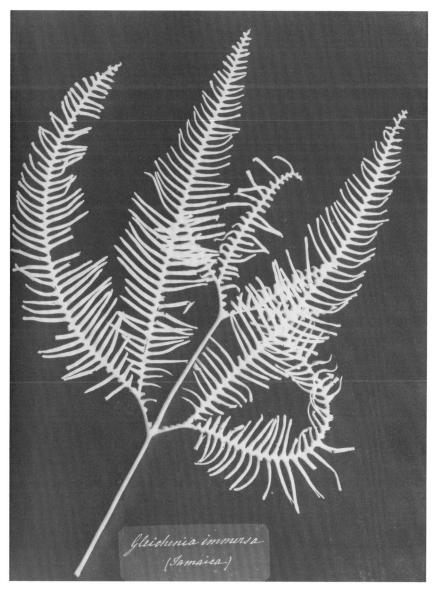

CYANOTYPE

Anna Atkins (British, 1799–1871), Gleichenia Immensa (Jamaica), from Cyanotypes of British and Foreign Ferns, 1853. Cyanotype, 25.4 \times 20 cm (10 \times 7% in.). JPGM, 84.X0.227.90.

fifteen-minute EXPOSURE, a white impression had formed, where the light had not penetrated, on a blue ground. The paper was then WASHED in water to remove unexposed iron salts, rendering the paper insensitive to light. Over time, oxidation of the image intensified the brilliant cyan color (Prussian blue) that gives the process its name. A variant of this process was used for years to duplicate architects' drawings (blueprints).

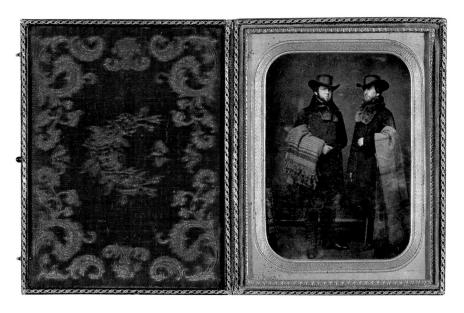

DAGUERREOTYPE

John Frederick Polycarpus von Schneidau (American, b. Sweden, 1812–1859), *Two Travelers*, 1852–55. Half-plate daguerreotype; image (inside mat) 11.4 × 8.3 cm (4½ × 3¼ in.); case (closed) 15 × 12 cm (5½ × 4¾ in.); and outside cover. JPGM, 84.XT.1565.29.

DAGUERREOTYPE

A *daguerreotype* is a highly detailed image formed on a sheet of copper very thinly plated with silver. Extremely thorough, even exhaustive, cleaning and polishing of the silver was the first essential step in the making of a daguerreotype. Next came the suspension of the shiny plate over iodine in a closed container. Rising vapors from the iodine united with the silver to produce a LIGHT-SENSITIVE surface deposit of silver iodide. The sensitized plate, inside a lightproof holder, was then transferred to a camera and, in the earliest days, exposed to light for as long as twenty-five minutes.

The plate was DEVELOPED by placing it in a container suspended over a heated dish of mercury, the vapor from which reacted with the exposed silver iodide to produce an image in an amalgam of silver mercury. The image was fixed by immersion in a solution of salt or sodium thiosulfate and TONED with gold chloride to improve its color, contrast, and permanence. The image thus produced had startling clarity.

Daguerreotypes are highly vulnerable to deterioration in the form of physical damage from abrasion and chemical damage from tarnishing. Therefore, they were normally protected by a metal MAT and a covering sheet of glass, which were sealed at the edges with tape and fitted into a booklike case made of wood-covered leather or primitive plastic (compressed sawdust and resin) and lined with dark velvet (see Cased Photograph). As the image, which is actually a negative, lies on the surface of a highly polished plate, to be seen as a positive it must be held at an angle to minimize reflections. The shadows in a daguerreotype appear to recede, creating an illusion of depth. The earliest daguerreotypes have laterally reversed images, as in a mirror; later, to correct this reversal, an actual mirror was placed at an angle in front of the lens when the exposure was made, and the reflection of the subject was then photographed.

The announcement in Paris in 1839 of the invention of this process by Louis-Jacques-Mandé Daguerre (1787–1851), who had appropriated the research of Nicéphore Niépce (1765–1833), was widely acclaimed. Refinements of technique and equipment, which followed immediately, considerably reduced exposure times and made the daguerreotype wildly popular as a medium for portraiture until the middle of the 1850s, when it was succeeded by the AMBROTYPE, even though the latter was not inexpensive. Its grayish white tones were often modified by the delicate application of color, heightening the apparent realism of the portrait.

DARKROOM (DARK CHAMBER)

Because of the LIGHT-SENSITIVE properties inherent in photographic materials, a darkened enclosure has always been necessary for a photographer, whether for the initial sensitizing of the negative material (which was done by the photographer in the early years of photography), for the DEVELOPMENT of the negative, or for making prints. Such enclosures have taken many forms, from the nineteenth-century traveling photographer's portable tent or van to modern-day *darkrooms*. The essential components of darkrooms have varied with the changing nature of photographic processes.

DENSITY

The technical term *density* indicates a precise measurement of the amount of light absorbed and reflected by a particular area of a photographic print or, in the case of a NEGATIVE OR TRANSPARENCY, transmitted through an area of the image. Density results from the amount of silver or color dye deposited in a specific area of a photograph in its making and may be used to describe the work's tonal range. In the nineteenth century, density was inexactly measured by eye. Today density measure-

ments are made with an electronic device called a *densitometer*, first proposed jointly in 1890 by Ferdinand Hurter (1844–1898) and Vero Charles Driffield (1848–1915). By recording the densities at a series of points on a print before and after exhibition, one can determine if prolonged exposure to gallery lighting has altered a photograph. Density measurements of negatives are also used by photographers to determine optimum exposure times for the production of prints from these negatives.

DEPTH OF FIELD

In describing a photograph, the term *depth of field* refers to the extent to which the space surrounding a subject—both that beyond the subject and that between the subject and the camera—appears to be sharply defined. If foreground, middle ground, and background all seem to be in focus, the work can be said to have great depth of field; see, for example, the illustration below. Technically, depth of field is dependent on the focal length of the camera LENS, the size of the camera APERTURE, and the distance of the camera from the subject.

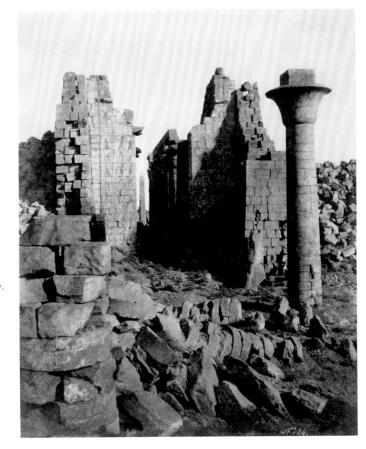

PEPTH OF FIELD
Henry Cammas
(French, 1813–after
1879), Column and
Obelisk from the
Temple of Amon,
Karnak, 1860. Salt
print from a waxed
paper negative,
30 × 24.4 cm
(11¹³/16 × 9⁵/8 in.).
JPGM, 84.XM.1016.17.

DETERIORATION

Photographic materials are subject to three main kinds of *deterioration:* chemical, physical, and biological. Most forms of deterioration are irreversible but can be avoided by careful handling and the choice of appropriate storage enclosures and exhibition environments.

Photographs that contain silver (see SILVER SALTS) are subject to chemical silver corrosion reactions that change the appearance of the image. Fading and a color shift from a neutral tone to brown, even yellowish, hues are typical results of oxidation that breaks down the silver particles that make up the image; reactions to airborne sulfur are also common and result in brownish tones. Prolonged exposure to light can cause damage to images, and high-energy ultraviolet (UV) radiation, which is present in daylight, is capable of degrading organic molecules in photographic materials: EMULSION BINDERS such as ALBUMEN and GELATIN typically darken and yellow. Chemical deterioration is generally accelerated by high humidity, high temperatures, and environments or enclosures that contain aggressive substances such

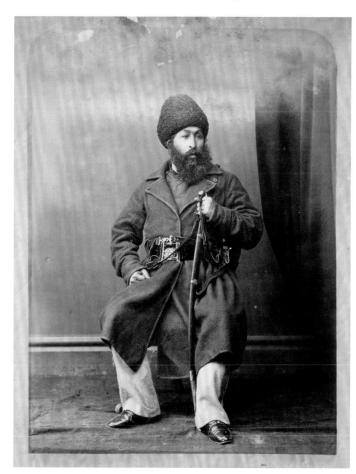

John Burke (Irish, 1843–1900, active India), *H. H. The Amir Shere Ali Khan*, 1869. Albumen print showing fading, water and mold staining, and damaged mount, 27.6 × 20.8 cm

(10⁷/₈ × 8³/₁₆ in.). JPGM, 84.XO.1277.95.

DETERIORATION

29

as acids or sulfuric compounds. Poor processing may also be the cause of chemical deterioration if residual substances such as FIXER (sodium thiosulfate) are not properly WASHED out. In this case, the deterioration of the image may be evident in local staining or overall discoloration.

Physical deterioration is often apparent on prints that have been subjected to excessive handling: surface abrasion, scratches, dents, creases, fingerprints, stains, accretions of dirt, and breaks in the emulsion are common.

Mold growth is the most common form of biological deterioration. Gelatin emulsions are especially susceptible to fungal damage, since gelatin can nourish spores. Mold growth becomes most acute when photographic materials are stored in areas of prolonged high humidity and stagnant air. See also FOXING.

DEVELOPING-OUT PAPER

Developing-out paper is designed for the production of photographic prints from NEGATIVES by chemical DEVELOPMENT rather than by the action of light alone (see PRINTING-OUT PAPER). Developing-out papers (sometimes abbreviated D.O.P.) for ENLARGEMENT using artificial light are coated with a silver bromide EMULSION, usually made of GELATIN, that is highly sensitive to light. Early developing-out papers for CONTACT PRINTING by artificial light carried a silver chloride emulsion. (During the gaslight era, this second kind of developing-out paper was sometimes called gaslight paper because it could be prepared in dim gaslight, exposed in full gaslight, and developed in dim.) Both types are briefly exposed to light under a negative and then chemically developed to produce a visible image. Developing-out papers were available from 1873 onward; having been substantially improved, they had become popular by 1880, and after 1900 they were preeminent. They were the ancestors of modern Gelatin silver photographic papers. The images produced are neutral in tone unless altered by chemical Toning.

DEVELOPMENT

This basic step in the production of a photograph began with the discovery in 1840, by William Henry Fox Talbot (1800–1877), that, after exposure in a camera, a Negative contained an invisible or latent image that could be chemically transformed into a visible image. *Development* generally consists of immersing the negative in a bath containing chemicals specific for each kind of negative material in order to bring forth the visible image. This process is delicate, requiring careful control of the composition of the processing solutions, bath temperature, and processing time. In Developing-out processes, prints made from the negative are also developed. It is during development that the exposed SILVER SALTS are transformed into the metallic silver that makes up the final image of most black-and-white photographs. Development is followed by Fixing and Washing.

DICHROMATE PROCESSES See BICHROMATE PROCESSES.

DIGITAL EXPOSURE TO PHOTOGRAPHIC MATERIALS / DIGITAL OUTPUT PHOTOGRAPH

Since photographic materials are by nature LIGHT-SENSITIVE, they can be EXPOSED both traditionally, as, for example, FILM in a camera and photographic paper from a NEGATIVE, as well as by other means of applying light to the EMULSION, such as a digital exposure. In principle, digital exposure goes back to the early twentieth century, but a modern technique that uses lasers became popular in both amateur and professional applications in the late 1990s. Many artists and photographers have their DIGITAL IMAGES printed on large-format CHROMOGENIC OF DYE DESTRUCTION paper, and since about 2000 almost all amateur color prints have been made by digital exposure.

This digital print process may be regarded as a hybrid technique, because it combines both the advantages of digital imaging and the use of traditional, light-sensitive photographic materials. In a type of printer called a *digital enlarger*, a digital image is exposed pixel by pixel and line by line to a photographic paper. Moving laser beams and arrays of light-emitting diodes (LEDs) are most commonly used for converting the electronic signals conveyed from the computer into pinpoint exposures with precisely controlled color and brightness levels. In devices called *film recorders*, negative or positive film is digitally exposed in much the same manner. Following exposure, the photographic material is chemically processed. It can be very difficult to identify the resultant photographic print or film as having had a digital source; only by means of microscopic examination (if at all) can a slight grid be observed that resembles the regular pixel pattern of the digital image source or that is a result of the linear exposure mechanism.

DIGITAL IMAGING / DIGITAL IMAGE

These terms are generally used to describe a form of image creation and manipulation that is based on a numerical (i.e., digital) system. *Digital imaging* may be understood as a parallel realm of technologies that has, over the past forty years, evolved alongside that of traditional photographic processes (characterized by light-sensitivity and chemical processing), and both are subsets in the wide range of *imaging processes*.

Digital imaging is based on the *binary* system, in which there are only two possible states: present or not present, on or off, one or zero, etc. A *digital image* that resembles a traditional photograph is generally obtained by converting rays of light into a binary form. This occurs, for example, in a scanner (a device that digitizes an already existing photographic print or TRANSPARENCY) or in a digital camera (the image is referred to as being "*digitally born*"), in which varying amounts of light reflecting off the photographed subject are projected through a LENS onto a small chip (called a *charge-coupled device* [CCD]) that has, on one side, a regular grid of minute, rectangular, LIGHT-SENSITIVE electronic sensors. The different amounts of light received are converted into a range of electronic signals, each of which is described by a sequence of binary digits (Is and 0s) that can be processed by a computer or other digital device. The resulting digital image is made up of a grid of

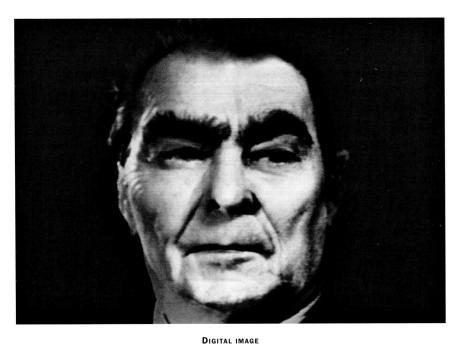

Nancy Burson (American, b. 1948), *Warhead I*, 1982. Gelatin silver print, 27.9 × 35.6 cm (11 × 14 in.).

Museum of Photographic Arts, San Diego, 89.015.002. © Estate of Nancy Burson.

individual picture elements, called *pixels*, each pixel holding the binary information for that minute portion of the image. Depending on the information within each pixel, the image appears as either black and white (called *grayscale* in digital imaging) or color. This information is electromagnetically stored as a digital file on a computer disc or other storage medium. The digital image by itself is not comprehensible to the human eye—an electronic device such as a computer with a monitor and a translator (that is, some form of software) are necessary for converting the information into coherent visual form.

With software, images can be manipulated in size, color, contrast, and brightness, and they can be altered with a large number of RETOUCHING tools. With or without this type of manipulation, the images can be regenerated, via various mechanisms, through telecommunication systems such as the Internet and e-mail and, as a luminous image, onto a monitor; with a number of DIGITAL PRINT techniques, the images can also be printed onto photographic materials or paper.

At an amazing speed since the mid-1990s, digital processes and devices have revolutionized most forms and technical processes of photography. By the middle of the first decade of the new millennium, most photographers had at least experimented with scanners, digital cameras, and imaging systems, if not completely switched to new techniques. Owing to the resulting lack of demand in the amateur and professional markets, the range of available photographic papers and films has radically diminished. Many artists have explored the opportunities that digital imaging offers, and it remains a technology in flux.

DIGITAL NEGATIVE

The term *digital negative* is usually used for a DIGITAL IMAGE that was taken with a digital camera. The file that is generated in the camera is analogous to the traditional photographic NEGATIVE in that it holds all of the information necessary for creating a final version of the image. A digital negative is also called a *raw* image file, and, in order for it to become a final image, it is DEVELOPED with software made specifically for the task.

The term is also sometimes used for a negative image that has been created with digital image manipulation software, then printed with a digital print process in order to be used as a negative for contact printing employing historical photographic processes such as printing-out paper, other silver salt papers, iron salt, or bichromate materials.

DIGITAL PRINT

Although the term *digital print* has not been satisfactorily and precisely defined to date, it is generally understood to describe prints from DIGITAL IMAGE files. A digital print is created either by applying coloring agents to a support that may be paper, plastic, textile, or another material (see INKJET PRINT, DYE DIFFUSION THERMAL TRANSFER PRINT, ELECTROPHOTOGRAPHIC PRINT, and PHOTOTHERMOGRAPHIC TRANSFER PRINT) or by generating the color within special surface coatings on the support (see DIGITAL EXPOSURE).

Digital printing differs from traditional printing methods in that the resultant prints have as an immediate origin an electronic signal (the digital image file), and in that they have not been produced from a matrix such as a printing plate or a mold or from a photographic negative. (They are therefore also called *nonimpact* prints.) Because there is no master, each print can, if desired, look quite different from all others made before and after it. Since the mid-1990s, digital files have rapidly replaced traditional negatives and TRANSPARENCIES, and digital printing techniques have become commonplace in both amateur and professional photography.

DIMENSIONS

In stating the measurements of photographs, height is given before width, and *dimensions* are usually stated metrically and in inches. Normally it is the size of the image itself that is measured rather than the size of the sheet on which it appears, although both image and sheet sizes are recorded in most museum databases.

DIRECT-POSITIVE PRINT

The term *direct-positive* can be used to refer to the result of any photographic process in which a positive image is produced on paper, glass, or metal, without a separate negative. Several modern processes fall under this rubric, including those for making transparencies and dye destruction prints. A narrower use of the term denotes simpler nineteenth-century processes, most notably that of Hippolyte Bayard (1801–1887). In 1840 and shortly afterward, Bayard produced images by

DIRECT-POSITIVE PRINTHippolyte Bayard (French, 1801–1887), *Still Life with Statuettes*, 1839.
Direct-positive print, 13.1 \times 12.8 cm ($5\frac{1}{2}$ 8 \times 5 $\frac{1}{2}$ 16 in.). JPGM, 84.XM.261.2.

coating a sheet of writing paper with silver chloride, nearly exactly as William Henry Fox Talbot (1800–1877) had done for his photogenic drawings. Unlike Talbot, Bayard proceeded to expose the paper to light until it blackened. After dipping the blackened sheet in potassium iodide, he placed it on a sheet of slate in a camera, where, during exposure, the iodine bleached out the paper in proportion to the light received, forming a positive image. As a fixer, Bayard employed sodium thiosulfate, a compound previously discovered by Sir John Herschel (1792–1871), to remove SILVER SALTS. The print was then WASHED. Each print was unique as it had no negative. To obtain another print of the same image, the subject had to be photographed again. Bayard's direct-positive prints can vary in hue from red to dark orange and yellow, even purple-green, and the image is often so softly rendered as to appear "as if through a fine curtain of mist" (Francis Wey, 1851).

DISCOLORATION See DETERIORATION.

DODGING

When photographers determine that dark areas of a CONTACT PRINT OF ENLARGED print are too dense or show inadequate detail in the shadows, they can employ dodging as a technique to reduce that DENSITY. Dodging consists of interposing for part of the EXPOSURE in an enlarger a piece of card, tin, plastic, or aluminum attached to the end of a thin stiff wire, between the beam of light coming through the NEGATIVE via the enlarging LENS and the photographic paper being exposed. The shadow cast by the card reduces the exposure on that area of the print, leaving it lighter in tone or showing greater detail. To avoid creating a sharp outline around the shadowed area, the photographer continuously jiggles the dodging instrument gently back and forth. If dodging while contact printing, the photographer interposes the card between the light source and the negative. For a related technique, see BURNING-IN.

DOUBLE EXPOSURE

A *double exposure* results from the (presumably) intentional second exposure in a camera of a NEGATIVE OF TRANSPARENCY in order to produce a superimposition or

DOUBLE EXPOSURE

Frederick Sommer (American, 1905–1999), *Max Ernst*, 1944. Gelatin silver print, 19.3 × 24.1 cm (7 % × 9 ½ in.). JPGM, 86.XM.515. © Frederick and Frances Sommer Foundation.

combination of two images in a single photographic image. Multiple exposures, also for artistic effect, are likewise possible, particularly with the aid of FLASH lighting.

DRY PLATE

In general, *dry plate* refers to any GLASS PLATE coated with a dried LIGHT-SENSITIVE material. The first true dry plates were of glass coated with ALBUMEN containing SILVER SALTS. As they were less sensitive and therefore required much longer EXPOSURES than WET COLLODION plates, these dry plates were little employed. So-called DRY COLLODION plates (which were in fact very slightly damp rather than dry) also required longer exposures than wet collodion, and they, too, were little used. The term *dry plate* most commonly refers to a thin glass plate coated with a GELATIN EMULSION containing silver salts used to create a negative in a camera. The first practical plates of this type were invented in 1871 by Richard Maddox (1816–1902) and, after a period of rapid evolution, were in general use by the mid-1880s; they are still available, although infrequently used, as FILM-based negatives proved more practical. Dry plates wholly supplanted wet collodion as they did not require messy, last-minute chemical preparations and were more light-sensitive. Photographers normally bought the plates already sensitized, of a size to fit their cameras, although in the early days some photographers coated their own.

DRYSTAMP See BLINDSTAMP.

DYE DESTRUCTION PRINT (SILVER DYE BLEACH PRINT)

Silver dye bleach EMULSIONS were introduced in 1964. Before 1991, they were known by the trade name Cibachrome and after 1991 as Ilfochrome for both print and FILM used to make enlargements from color transparency positives. The emulsion has three main layers, each of which contains SILVER SALTS that have been SENSI-TIZED to one of the three primary colors of light: red, green, and blue. Each layer records different information about the color makeup of the image (the red-sensitive layer "remembers" red, and so on). Each layer also contains the dye complementary to the color to which the layer is sensitized: the red-sensitized layer contains cyan dye; the green layer, magenta; and the blue layer, yellow. During exposure from a transparency, a LATENT IMAGE of silver is formed in each layer. This silver image is DEVELOPED and then bleached out and, with it, a proportional amount of the associated dye is also destroyed. The print is then FIXED and WASHED. When seen on the white print stock, the residual dyes in the three layers appear as a single full-color image. Prints may be either on RESIN-COATED PAPER or, more commonly, on opaque polyester bases that have highly glossy surfaces. Typical of this positive print material are, where visible, black margins instead of white ones. The vibrant dyes in a dye destruction print are relatively resistant to fading and are considered more lightfast than are the dyes in CHROMOGENIC PRINTS.

DYE DESTRUCTION PRINT (SILVER DYE BLEACH PRINT)

Eileen Cowin (American, b. 1947), *Untitled*, 1981. Silver dye bleach print (Cibachrome), 47.3×58.8 cm ($18\% \times 23\%$ in.). Los Angeles County Museum of Art, Graphic Arts Council Curatorial Discretionary Fund, M.84.17. © Eileen Cowin.

DYE DIFFUSION PRINT See INSTANT PRINT

DYE DIFFUSION THERMAL TRANSFER PRINT (DYE SUBLIMATION PRINT)

This digital print process renders prints that have continuous tone and a wide range of colors and are, to the casual observer, indistinguishable from Chromogenic prints on resin-coated paper and from photothermographic transfer prints (Fuji Pictrography), due to their high image quality. *Dye diffusion thermal transfer* (abbreviated D2T2) prints have been used since the mid-1980s. They are, in general, more susceptible to fading when exposed to light than are photographic color prints.

The process employs a polyester ribbon that is coated with patches of yellow, magenta, and cyan dye that is transferred to a receptor sheet by the application of heat and pressure. The dye is heated rapidly until it becomes motile and diffuses into the receptor coating of the resin-coated paper support. When the dye cools, it binds to the coating, and the now-superfluous ribbon is peeled off the surface of the receptor sheet. Each color separation is transferred in sequence and in precise registration; once all the transfers are made, a full-color image results.

DYE TRANSFER PRINT (DYE IMBIBITION PRINT)

William Eggleston (American, b. 1939), *Between Memphis and Nashville*, ca. 1973. Dye transfer print, 31.8 × 46.4 cm (12½ × 18¼ in.). JPGM, 99.XM.13.6. © Eggleston Artistic Trust.

DYE TRANSFER PRINT (DYE IMBIBITION PRINT)

The terms dye transfer and dye imbibition describe a class of color prints made by a series of related processes in which three precisely registered layers of dye are superimposed on a GELATIN-coated base. Generally, from a color TRANSPARENCY, three separation NEGATIVES are made by photographing or EXPOSING the original successively through red, green, and blue filters onto black-and-white negative FILM. Each negative thus carries information about a different part of the color composition. From each negative a so-called matrix is made by CONTACT exposure. These matrix films are developed in a tanning (i.e., a hardening) solution, which solidifies the gelatin relative to its degree of exposure. The superfluous gelatin is washed away, leaving a surface that has a relief of areas with more or less hardened gelatin. Each of the three matrix films is placed in a different dye bath, the color of the dye being the complement of the color of the filter by which its separation negative was made (the red matrix is placed in cyan, the green in magenta, and the blue in yellow dye). The gelatin coatings of the matrix films absorb dyes from the baths and form positive images. The matrices are then successively applied in exact alignment to gelatincoated FIBER-BASED PAPER. The dyes diffuse into the gelatin coating of the paper, thereby producing a full-color image within it. The dye transfer process, which was used from the 1940s until the mid-1990s, is time consuming but permits considerable control of results and produces a relatively permanent print that does not contain silver. For a related earlier process, see CARBRO PRINT.

EDITION

An *edition* is created when a photographer decides for commercial purposes to set a maximum number of prints from a negative or positive and indicates the limitation by serially marking each print with two numbers in the form of a fraction. The numerator denotes the position of the print in the sequence, presumably in the order actually made, and the denominator the total number of prints. This practice is borrowed from traditional printmaking processes and is now also (often inexactly) applied to editions of inkjet prints.

ELECTROPHOTOGRAPHIC PRINT / COLOR LASER PRINT

Electrophotography was introduced to the market with the first automatic copier, the Xerox 914, in 1959, and the technology now forms the basis for a range of copiers and printers. In the mid-1980s the first electrophotographic devices that were

ELECTROPHOTOGRAPHIC PRINT

David Hockney (British, b. 1937), 40 Snaps of My House, August 1990 (detail). Color laser print from video stills, 21.6 × 27.9 cm (8½ × 11 in.). Gift of David Hockney. Jpgm, 92.xm.30.11. © David Hockney. The magnified detail reveals a linear screen pattern that is made up of tiny particles of toner that have been fused to the surface of the paper.

capable not only of copying in color but also of printing out color digital images became available—these are generally called *color laser printers*. Although not typically used for printing photographic images, laser printers and copiers have been used by artists and photographers often enough to number electrophotography among the typical printing processes for digital images. Electrophotography employs a halftone screen that is often too fine to be seen by the naked eye. Brilliant colors can be achieved and simple, office copy paper used.

As implied by its name, *electrophotographic printing* involves using both light and electrostatic charges; in addition, there is a transfer and a fusing step. The process is dependent on the use of a LIGHT-SENSITIVE drum, one or more of which being at the heart of each copier or printer. The electrostatically charged surface of the rotating drum is selectively discharged by exposure to light in the form of precisely controlled lasers or light-emitting diodes (LEDs). The exposure produces a LATENT IMAGE on the surface of the drum that consists only of charged and noncharged areas. Minute particles of pigment mixed in a resin, called *toner*, are either attracted to the latent image or repelled from it and, in the first case, temporarily adhere to the surface of the drum until they are transferred from there to the surface of a sheet of paper. In a final step, the toner is fused to the paper surface with heat and pressure: the resin melts, adheres to the paper fibers, and hardens as it cools down. As each color separation (typically yellow, magenta, cyan, and black) is transferred in sequence and in precise registration, a full-color image, made up of individual half-tone screens, is formed.

EMULSION

A number of photographic materials, such as FILM, DRY PLATES, and most printing papers, have on their surface as a LIGHT-SENSITIVE coating an emulsion consisting of silver halide crystals suspended in GELATIN. (In general terms, an emulsion consists of small undissolved units of one substance held in uniform dispersion in another substance, initially liquid or semiliquid in form, as, for example, mayonnaise consists of particles of oil held in egg yolk.) The light-sensitive SILVER SALTS are silver bromide, silver chloride, and silver iodide, collectively referred to as silver halides. The properties of these halides vary, and other ingredients are added, depending on the use for which the emulsion is intended. (See also GELATIN SILVER PRINT.) In the nineteenth century, ALBUMEN and COLLODION were the primary means of attaching silver halide crystals to supports, but the halides were added to these BINDERS only during processing and rested on the surfaces of these substances rather than being suspended within them. The first true photographic emulsions were introduced with dry plates in the early 1880s. Emulsions became popular on collodion and gelatin DEVELOPING-OUT PAPERS toward the end of the nineteenth century. All modern photographic materials use emulsions.

ENLARGEMENT

Alexander Gardner (American, b. Scotland, 1821–1882) and Mathew Brady (American, ca. 1822–1896), *Tateisi Owasjere, Interpreter for the Japanese Delegation*, 1860. Solar-enlarged albumen print from a wet collodion on glass negative, 38.2 × 31.7 cm (15 × 12½ in.).

JPGM, 84.XM.479.33.

ENLARGEMENT

An *enlargement* is a photographic print of greater dimensions than the NEGATIVE or POSITIVE from which it was made. (A CONTACT PRINT, in contrast, is always the same size as its negative.) Making an enlargement involves projecting light, usually by means of a Lens, through a negative or positive onto LIGHT-SENSITIVE paper of the desired size. The quality of the enlargement (tonal range, sharpness, contrast, degree of details, and so on) is mainly dependent on the optics of the enlarging apparatus. Enlargement can also be used to make an enlarged Transparency from which, in turn, a contact negative and then a single print or series of same-sized prints can be produced. Although solar enlargers were occasionally used in the nineteenth century, enlargements became truly practicable only with the advent of Developing-Out silver bromide emulsions, which were sensitive to comparatively weak electric or gas light.

The advantages of enlarging are twofold: to increase the scale of the finished print and to shrink the size of the CAMERA used to produce them, making unnecessary the cumbersome cameras of the GLASS PLATE era. (See also BURNING-IN and DODGING.)

EXPOSURE / APERTURE / SHUTTER

Alma Lavenson (American, 1897–1989), Self-Portrait, 1932.

Gelatin silver print, 20.3 × 25.2 cm (8 × 91%6 in.). JPGM, 85.XP.283.5. © Alma Lavenson Associates.

EXPOSURE / APERTURE / SHUTTER

Exposure refers to the quantity of light that falls on a LIGHT-SENSITIVE material. In a CAMERA, for example, exposure is governed by the length of time the NEGATIVE or TRANSPARENCY (or, in digital cameras, the small chip called a *charge-coupled device*, or *CCD*) receives light and by the size of the opening (*aperture*) through which the light passes. Exposure length is determined by the speed with which the *shutter* opens and closes, allowing light to pass through the aperture. The speed can be varied, as can the diameter of the aperture. It is the coordination of these two factors that determines optimum exposure.

Early cameras did not have shutters. Exposure times were so long that the photographer could manually remove and replace a cap over the LENS. Today's cameras typically have electronically operated, accurate, high-speed shutters. Early aperture control was by means of a set of circular brass plates with holes of various sizes, one of which was positioned in front of, behind, or between the elements of the lens. Modern aperture controls, known as diaphragms, are highly sophisticated and are built into the lens. Aperture settings today are referred to by a numbering system known as *f-stops*, a ratio of the diameter of the aperture to the focal length of the lens.

FACE MOUNTING

A form of presenting a finished print, *face mounting* became popular in the late 1980s and has been used increasingly since then. The technique consists of adhering the face, or EMULSION side, of a photograph, most commonly a large-format CHROMOGENIC PRINT, to a sheet of transparent, rigid acrylic that thereby functions as both its MOUNT and its glazing. The adhesive used is either a silicone rubber or a double-sided adhesive film. Both must be colorless and extremely clear. Face mounting greatly enhances the saturation of the colors of a photographic print and lends to it the highly glossy surface of the acrylic glazing. This surface is, unfortunately, very susceptible to abrasion, so much care must be taken when handling, storing, and transporting face-mounted photographs.

FADING See DETERIORATION.

FERROTYPE See TINTYPE.

FIBER-BASED PAPER

This is a general term for a photographic printing material that consists of a support of high-quality paper coated on the front with a white, opaque layer of baryta (barium sulfate dispersed in Gelatin) and, on the surface of this layer, a photographic Gelatin Emulsion. Although sometimes used for the Developing-out papers that dominated the market after the late 1920s, the term *fiber-based paper* became common only after the early 1970s and is used to distinguish this kind of paper from RESIN-COATED PAPER. See also GELATIN SILVER PRINT.

FIELD CAMERA See VIEW CAMERA.

FILM

In photography, *film* generally consists of a thin, transparent, flexible, but relatively durable sheet that is used as a support for NEGATIVES OF TRANSPARENCIES. Typical examples are cellulose nitrate, cellulose acetate, and, more recently, polyester films for still photography and motion pictures. Both cellulosic film materials have proved to be highly unstable in the long term, and they suffer severe chemical and physical DETERIORATION if not stored appropriately.

FIXING

Fixing is a critical step in the production of a photograph. After the DEVELOPMENT of a NEGATIVE, a TRANSPARENCY, or a print, LIGHT-SENSITIVE SILVER SALTS are still present in unexposed areas of the photographic materials and must be removed to render the photograph insensitive to light. To accomplish this, photographic materials are immersed in one or more successive baths of fixer to prevent further chemical reactions. Careful timing and control of the chemical ingredients are required. Sir John Herschel (1792–1871) first suggested in 1839 that "sodium hyposulphite" could

be used to fix photographs. Although the modern chemical term used today for this compound is sodium thiosulfate, photographers still tend to call all fixers "hypo" even though other chemicals (such as ammonium thiosulfate) may also be used. Sodium thiosulfate works as a fixer because it is capable of dissolving SILVER SALTS, which are otherwise insoluble in plain water. As a final step in photographic processing, thorough WASHING is important in order to remove the residual fixer from the negative, transparency, or print and thus prevent later chemical DETERIORATION of the silver image. (Sulfur components of fixers can oxidize the image silver and form brown silver-sulfide stains.)

 $\label{eq:Flash} \textbf{N} \textbf{adar} \ (\textbf{Gaspard-Félix Tournachon}) \ (\textbf{French}, 1820-1910), \textit{Paris Catacombs}, 1865.$ Albumen print, 22.5 × 18.2 cm (87/8 × 71/4 in.), showing magnesium lamp in lower right corner. JPGM, 84.XM.436.481.

FLASH

A photographic *flash* is the addition, for an instant, of supplemental light of high intensity to a photographic subject in order to produce a better-exposed negative or transparency and thus a more visible final image. Perhaps the earliest device for this purpose was the magnesium flare used in the early 1860s. Modern devices include the flashbulb, strobe light, and electronic flash.

FOXING

The term *foxing* refers to brownish spots in paper. They are caused by chemical or metallic impurities introduced in the paper-manufacturing process, fungus and/or bacteria, which, when exposed to atmospheric moisture over time, cause staining in the paper and sometimes thereby on a photograph made on or mounted to that paper.

GELATIN

Gelatin is a protein extracted from animal wastes such as bones, hoofs, horn, and hides. It is a type of glue that, when dry, forms a transparent film that can repeatedly absorb and release water. Solids such as SILVER SALTS can easily be dispersed within a gelatin film. These characteristics make gelatin particularly suitable for use in photographic EMULSIONS, in which chemical processing is based on aqueous solutions. It has also found wide application in BICHROMATE processes. The gelatin used in photographic applications is of a superior quality and is made only from animal hides.

GELATIN SILVER PRINT / SILVER BROMIDE PRINT / SILVER CHLORIDE PRINT

Soon after the invention of the gelatin DRY PLATE in 1871, papers coated with GEL-ATIN containing SILVER SALTS for making black-and-white prints from NEGATIVES were introduced, and in the twentieth century, they became the papers most commonly used for black-and-white photographs. The silver salts contained in the gelatin EMULSION are principally *silver bromide* or *silver chloride* or a combination of both. As silver chloride is less sensitive to light than silver bromide is, papers containing silver chloride were used for early CONTACT PRINTING. Silver bromide papers were and are primarily used for ENLARGEMENTS. Papers with both salts—chlorobromide papers—can be used for either method of making prints.

In 1873 gelatin silver bromide papers were invented and first produced by Peter Mawdsley, although they did not come into general use until the 1880s. They were DEVELOPING-OUT papers rather than PRINTING-OUT papers, that is, after brief EXPOSURE under a negative, usually in an enlarger, the image was brought out by chemical DEVELOPMENT. Gelatin silver chloride papers for printing-out and for developing-out were both introduced in 1882. To make a printed-out photograph, the light-sensitive paper was placed under the negative under a light source until the image appeared in its final form, without chemical development. The exposure under the negative was necessarily much longer than for a developed-out photograph. Photographers of the 1880s and afterward did not coat their own papers but obtained

GELATIN SILVER PRINTAugust Sander (German, 1876–1964), *Group of Circus People*, 1926.
Gelatin silver print, 19.9 × 27.5 cm (7% × 10 1/16 in.). JPGM, 84.XM.498.5.

them from commercial sources. Gelatin silver prints had displaced Albumen prints in popularity by 1895 because they were more stable, did not yellow, and were simpler and quicker to produce. Gelatin silver papers that are fiber based most often have a baryta layer that creates a white underlying base for the image; those that are on a resin-coated paper support (popular from the 1970s onward) have a white-pigmented polyethylene layer under the emulsion.

Because of the great variety of papers offered by manufacturers, the tones and surface gloss of gelatin silver prints vary greatly. Generally, however, the tone of the image of a gelatin silver bromide print is neutral black. A gelatin silver print that has been developed-out is bluish black or cool in tone; one that has been printed-out (a comparative rarity in America after 1895) is brown or warm in tone. Prints made on paper containing both bromide and chloride have a warm, brownish black tone. All of these colors can be altered by TONING. The highlights are white unless the underlying support has been TINTED. Gelatin silver prints may be given high surface gloss by drying them against a heated sheet of smooth chromium, a process called ferrotyping (not to be confused with the FERROTYPE).

GHOST

If, during the long exposures required by nineteenth-century photographic processes, a person, animal, or carriage moved away from its initial position, a blurred, faint, residual impression of it remained on the NEGATIVE and appeared in the PRINT. This image is called a *ghost* from its transparent, whitish tone. Any exposure of a negative with a SHUTTER speed slower than about ½00 of a second can cause objects in motion to blur. Sometimes this fact was used intentionally to produce a ghostlike image. See also SPIRIT PHOTOGRAPH.

GHOST

Alexander Gardner (American, b. Scotland, 1821–1882), *St. Louis Office, Union Pacific Railroad*, 1867. Albumen print, 33.3 × 47.5 cm (13½ × 18¾ in.). JPGM, 84.XM.1027.8.

Enlarged detail shows ghost.

GICLÉE

In 1991, the printmaker Jack Duganne coined the term *giclée* (French: that which is sprayed or squirted) for INKJET PRINTS on high-quality paper. The use of the term was roughly analogous to the use of the term *serigraph* for a silkscreen and became immensely popular. Giclée was initially a synonym for an IRIS PRINT on good paper, but as an increasing number of print studios described high-volume editions of reproductions and posters as giclées, many studios making original art soon distanced themselves from the term. In consequence, the term *giclée* was used mostly for commercial art reproductions on fine art paper and canvas, not for artists' original prints. It is never used for inkjet prints on glossy resin-coated paper. When new, large-format inkjet printers became popular in the late 1990s, the term was also often used to denominate these non-Iris prints, but the term has become almost obsolete today.

GLASS / GLASS PLATE

In 1834, Sir John Herschel (1792–1871) presciently suggested that *glass*, because of its transparency, could be employed as a support for LIGHT-SENSITIVE materials. From 1850 onward, glass was used for Positives, such as the Ambrotype, or, more frequently, for photographic Negatives. Albumen, collodion, and Gelatin, carrying light-sensitive SILVER SALTS, have all been successfully employed for coating *glass plates* for use in the CAMERA. Glass has also been used for transparencies such as lantern slides and autochromes. The term *glass plate* most often applies to the collodion process. Plates of high-quality glass with ground edges were commercially available in standard sizes (see Plate). In the twentieth century, the term *glass plate* can be taken to refer to DRY Plates carrying gelatin emulsions.

GROUND GLASS

The light entering a CAMERA is projected by the LENS onto a sheet of glass with a granular textured, or ground, surface. This translucent stage is used for assessing, composing, and focusing the image, which appears exactly as it will be exposed to the photographic material in the camera. In VIEW CAMERAS, the image appears upside down, as projected by the lens, on the *ground glass*. In single-lens reflex (SLR) cameras, a mirror-and-prism system manipulates the light rays to show a corrected image.

GUM BICHROMATE PRINT

Introduced in 1894, popular into the 1920s, and occasionally used today, the gum bichromate process for making prints from negatives was valued for the high degree of artistic control it gave the photographer over the appearance of the final print. A *gum bichromate print* was made by brushing onto a sheet of paper a smooth coating of gum arabic (a transparent plant secretion) dissolved in water and mixed with a pigment and a solution of potassium (or ammonium) BICHROMATE. The coated paper was dried and EXPOSED in sunlight under a same-sized negative; that is, it was

GUM BICHROMATE PRINT Robert Demachy (French, 1859–1936), Jack Demachy, Age Eight, 1904. Gum bichromate print, 15.9 × 11.2 cm (61/4 × 47/6 in.). IPGM, 84.XM.806.5.

CONTACT PRINTED. The bichromate caused the gum arabic to harden in proportion to the amount of light received. For example, in what would be the highlights of the final print, the negative was dark. As a result, in the corresponding section of the print, the gum did not harden and could be washed away, leaving the highlight area light in tone. After exposure, the print was placed in water, and the part of the gum that had remained soluble slowly dissolved and was washed away. The photographer could influence this process by locally stroking or rubbing the surface with a brush or focusing a stream of water toward it to dissolve greater or lesser amounts of the pigmented gum arabic, thus changing the image contrast. The print was complete when dried.

Prints were often recoated a number of times with the same or a differently colored pigmented gum-arabic solution in order to alter, deepen, or enrich their tones, overall

or in specific areas. Then they were carefully aligned under the same negative, exposed again, and processed again. Gum bichromate prints usually have a narrow tonal range with little resolution of detail, and they often resemble crayon or charcoal drawings or watercolors. As they do not contain silver in the final image, they are relatively permanent.

HALATION

Edgar Degas (French, 1834–1917), Louise Halévy by Lamplight, 1895. Gelatin silver print, 40.4 × 29.5 cm (1578 × 1178 in.). JPGM, 86.XM.690.2.

HALATION

This technical term refers to a halo of light around a bright object in a photograph, such as a window, lamp, or streetlight. *Halation* occurs in the NEGATIVE or in the POSITIVE printing process because excess light rays from the brilliant object reflect back from the EMULSION support, whether GLASS or FILM. Antihalation coatings exist to eliminate such reflections.

HALFTONE

The *halftone* technique refers to the transformation of the continuous tones of a photographic image, from the whites through the grays (the halftones) to the blacks, into the discontinuous tones of an image printed by means of a photomechanical process. To create grays from a single tone of black printing ink, the ink can be deposited either in varying amounts (as in the photogravure processes) or in

HALFTONE
Unknown maker
(active 1890s), *Statue*of a Vestal, ca. 1895.
Halftone plate from
Robert Burn's *Ancient*Rome (London, 1895),
10.6 × 4.1 cm
(4³/16 × 15/8 in.). JPGM,
84.XB.273.1.

Enlarged detail shows the halftone dot pattern.

varying patterns of distribution over the page surface (as in the PHOTOLITHOGRAPHIC and LETTERPRESS processes). In the last two processes, the original photographic image is rephotographed through a gridded screen that breaks up the image into a pattern of dots of various sizes, depending on the relative darkness of the original. (These dots are so small that the eye sees them not as dots but as varying shades of gray.) This new image, which has been, in effect, filtered through the screen, can then be transferred to a printing plate for printing.

In the photogravure processes, the continuous tones are broken into discontinuous tones by dusting the printing plate with powdered resin (called a grain) that diffuses the image. This is similar to the grain used in the traditional aquatint printmaking process.

Today, halftone screens are generated by software within the DIGITAL IMAGING workflow that has become the basis for practically all commercial printing.

HAND-COLORED PHOTOGRAPH

Unknown maker, Japanese school, *Buying Flowers*, ca. 1885. Hand-colored albumen print, 12.8 \times 17.4 cm (5 \times 67% in.). JPGM, 84.XA.765.8.4.

HAND-COLORED PHOTOGRAPH

Various means have been used since the days of the daguerreotype to add color manually to the surface of black-and-white photographs, including watercolor, other paints, and dyes. Brushes, cotton swabs, and airbrushes are used for application. *Hand-colored photographs* are to be distinguished from TINTED ones.

HELIOGRAVURE See PHOTOGRAVURE.

HOLOGRAM

A *hologram* (from Greek *holos:* whole) is an image in three dimensions made on a photographic plate, but it is generally not strictly viewed as a photograph. Although holograms and photographs share the quality of being images and the characteristic of being made by the exposure of an emulsion surface to light directed by lenses, in other respects they differ. The principle of the hologram was invented by Dennis Gabor (1900–1979) in 1947 but became practical only in the early 1960s with the advent of lasers.

The technology and vocabulary for holography are complex, and several kinds of images are called holograms; what follows is a simplified sketch. One kind of hologram, a *transmission* hologram, is made by directing one of two parts of a lasergenerated beam of light toward an emulsion on a GLASS PLATE. The other part of the

beam is directed toward the subject of the hologram and reflected from the subject toward the emulsion. The coincidence of the two beams of light on the emulsion produces a mixture of the patterns each provides. The emulsion records the similarities and differences of light. (This is a little as if yellow and blue paint were mixed on a surface to produce green, but at each point on the surface the differences between yellow and blue as well as the resultant green were apparent.) If the finished glass plate is illuminated, again using a laser, the original recording of the light reflected from the subject becomes visible as an image that appears to have three dimensions and is produced in a space set up to receive it. A *reflection* hologram is made somewhat differently and can be viewed by reflected light without projection. Its image is contained in the many thin layers of which it is made. Reflection holograms are often to be found on present-day credit cards and the like.

INKJET PRINT

Inkjet has become one of the most popular digital printing almost any type of digital file on any type of support, be it an expiration date on product packaging, simple text on paper, a photographic-quality digital image on a resin-coated paper, or large-format advertising signage. A large number of process variants have been developed, many of them only for specific applications. This wide range of applications is in part due to the process's fundamental simplicity: minute droplets of liquid ink are sprayed onto a support.

Although the first practical inkjet printers appeared on the market in the 1950s, color printing of photographic-quality images became feasible only in the early 1990s. In the fine art sector, inkjet printing on etching-type papers became widely popular in the 1990s and these prints became known as GICLÉE prints. Since 2000, professional photographers especially have purchased inkjet printers that produce prints in color and black-and-white that easily reach, even surpass, traditional photographic prints in tonal range, sharpness, and, for color, in permanence. These prints may be marketed as PIEZO PRINTS or can carry similar names.

Inkjet printers are very sophisticated devices. Ink is sprayed by means of printheads, which contain technology on a microscopic level and are basically made up of two principal components: an ink reservoir that supplies the ink and a nozzle through which the ink is propelled. It is common for printheads to have a large number of nozzles packed closely together. To cover the whole width of the paper with dots, the printhead shuttles back and forth. Because the printed ink dots on the substrate may be as small as about five micrometers (millionths of a meter) in diameter, they are below the resolution limit of the human eye, resulting in a perceived continuous tone.

Inks come in many forms; for printing photographic images, water-based inks holding dyes or pigments are most common. For color prints, yellow, magenta, cyan, and black inks are used, although a number of additional colors have become common. Black and diluted gray inks are used for black-and-white inkjet prints. The substrates (often called *media*) typically consist of high-quality papers, which

INKJET PRINT

Mark Klett (American, b. 1952) and Byron Wolfe (American, b. 1967), *Low Water at Vernal Falls*, 2001. Inkjet print, 50.4 × 43 cm (197/8 × 167/8 in.).

JPGM, 2007.37.6.

© Mark Klett and Byron Wolfe.

The magnified detail reveals an irregular array of dots of four or more colors forming a pattern typical of the inkjet print.

have a matte surface, or resin-coated papers with glossy or semiglossy surfaces. Both types have an ink receptor layer that retains the ink dots close to the surface and makes them less sensitive to DETERIORATING agents such as water or light. The quality of the printed image and the variation in substrate and surface characteristics may be so high that often only a trained eye can distinguish an inkjet print from a traditional photographic print or other forms of digital prints.

INSCRIPTION

Oscar Gustave Rejlander (British, b. Sweden, 1813–1875), The Infant Photography Giving the Painter an Additional Brush, ca. 1856. Albumen print with inscribed title, 6×7.1 cm ($2^{3/8} \times 2^{13/16}$ in.). JPGM, 84.XP.458.34.

INSCRIPTION

Anything written or otherwise marked on the front or back (RECTO / VERSO) of a photograph, its mount, or, less frequently, its mat, is an *inscription*. Inscriptions can consist of the photographer's signature or BLIND- or WETSTAMP, or they can be made by someone else entirely, for example, a dedication of the photograph by one friend to another. (See also the illustration accompanying LANTERN SLIDE.)

INSTANT PRINT / DYE DIFFUSION PRINT

Instant print materials are characterized by the fact that they appear directly, within a matter of seconds or minutes, after the picture has been taken with a camera, without the necessity of external chemical processing. The Polaroid process, invented by Edwin Land (1909–1991), is an example of this technology. From 1948 onward, a SIL-VER SALT—based black-and-white instant process was marketed in which a NEGATIVE film was peeled off a POSITIVE print material. The first color instant print process, introduced in 1963, also relied on the *peel-apart* system. In 1973 the *integral* instant print system was introduced, in which all of the processing chemicals and layers were embedded in one single print material. Instant prints are unique.

Instant color prints are called *dye diffusion prints*. They contain three important elements: the negative EMULSION layers, a DEVELOPING paste, and the positive recep-

INSTANT PRINT /
DYE DIFFUSION PRINT
Andy Warhol (American, 1928–1987), Self-Portrait, 1986. Dye diffusion print (Polaroid), 10.8 × 8.6 cm (4 ¼ × 3 ¾ in.). JPGM, 98.XM.5-3. © The Andy Warhol Foundation for the Visual Arts. Inc.

tor layer. The emulsion of the print material has three principal layers, each sensitized with silver halides to one of the three primary colors of light: red, green, or blue. The layers are interleaved with associated layers containing both a dye reciprocal to the primary color and a developing agent. These layers plus a final backing layer comprise both the positive and negative and are contained in a sandwich that also holds a pod of developing chemicals. After exposure, the sandwich is expelled from the camera, passing under pressure through two rollers that break open the internal pod, thereby evenly spreading the developer throughout. As each layer develops, yellow, magenta, and cyan dyes diffuse to form the final image. In peel-apart materials, the negative layers are then stripped away from the positive. In integral packs, it is no longer necessary to strip away the negative materials, which remain embedded but not visible in the finished print. In black-and-white instant prints, it is not dyes that diffuse but rather silver salts, which are then developed, forming an image made up of metallic silver.

Since the rapid development of DIGITAL IMAGING systems and cameras in the mid-1990s, the use of traditional instant print materials, such as those produced by

Polaroid, has diminished greatly. New instant DIGITAL PRINT materials have been introduced that print by heat instead of light. (In a strict sense, they differ from traditional instant prints in that they are not dependent on exposure just beforehand.)

IRIS PRINT

The Iris Graphics printer was an INKJET device solely used for making proofs for commercial printing until, in 1991, it was adapted by the musician, photographer, and collector Graham Nash for printing digital images in editions for the photographic fine art market. A great variety of substrates could be used on an Iris printer, including papers, plastics, and textiles, giving the photographer a high degree of control over the resultant aesthetic and haptic quality of the digital print. Most popular were fine art, etching-type papers that, in combination with the precise control of ink placement and the resulting fine tonal values, created an aesthetic for prints of photographic images that had not been possible with traditional, chemistry-based photographic print materials. Although they have been marketed under the term giclée, often these inkjet prints are simply called *Iris prints*. Due to their technical complexity and the advent of newer printers that offered higher sophistication and ease, the use of Iris printers has diminished greatly since about 2005. Iris prints are known to be highly sensitive to deterioration. See also piezo print.

IRON SALTS

A number of *iron salts* have been used in photographic processes to render the materials LIGHT-SENSITIVE. In contrast to the processing of SILVER SALTS, which render final images that consist of silver particles, in most iron-based processes (such as the PLATINUM PRINT and the KALLITYPE), the iron salts act as catalysts for chemical reactions (generally a reduction of a ferr*ic* to a ferr*ous* salt) that reduce other metal salts to metallic particles such as platinum and silver. An exception is the CYANOTYPE, in which blue iron-based pigments are formed.

KALLITYPE / VAN DYKE PRINT

The *kallitype* is an IRON SALT photographic process devised about 1899 by W. W. J. Nicol and derived from the work of Sir John Herschel (1792–1871) in the 1840s. The process is analogous to that of the platinum print, and the results can look similar. A thick stock of paper was brushed with a solution of ferric oxalate, which is an iron salt, oxalic acid, and silver nitrate. This light-sensitive paper was contact printed under a negative, usually in sunlight, until the image began to appear. The print was then developed in one of several solutions, depending on the desired final image color.

The light had transformed the ferric oxalate to ferrous oxalate and thereby reduced the silver nitrate, producing an image in metallic silver. The print was then fixed with sodium thiosulfate and washed. Its color, which could be further

KALLITYPE

James G. Chapman (American, active ca. 1905), Column of the Temple of Castor, Roman Forum, ca. 1905. Kallitype, 12.2 \times 8.8 cm (4 13 /16 \times 3 12 2 in.). JPGM, 84.XB.273.1.16.

modified by Toning, could be black, brown, sepia, purple, or maroon. Because of alleged impermanence—Nicol's original formula for fixing was deficient—the kallitypes never achieved real popularity, although many variants of the process were announced. One kind of kallitype was known as a *van Dyke print*, as its rich, deep browns are thought to resemble those achieved by Anthony van Dyck (1599–1641) or those of the pigment named after him: van Dyke brown.

LAMINATE

Since the 1990s, some contemporary photographers have chosen to present their photographs mounted to rigid sheets of plastic or aluminum (see MOUNT) and have consciously rejected the use of the protective sheet of glass found in traditional frames, in order to create a new form of presentation that allows for a less mediated appreciation of what are often quite large images. Since the surface of photographic prints is very vulnerable to abrasion, fingerprints, liquids, and airborne humidity and pollutants, a protective, transparent plastic film may be adhered to the print. This *laminate* may have differing surface textures, its sheen ranging from dead matte to highly glossy. Typical plastics employed are polyvinyl chloride (PVC) and polyester, although a number of others have also been used. The long-term effects of the presence of a laminate adhesive on the print surface is as yet unknown.

LANTERN SLIDE

In the mid-nineteenth century, when a SLIDE projector was popularly called a magic lantern, a *lantern slide* was the source of the projected image. Originally an image painted on glass, a lantern slide became photographic in the 1850s with the use of an ALBUMEN or, later, COLLODION and, later still, GELATIN, coating on one side. All these kinds of coatings contained LIGHT-SENSITIVE SILVER SALTS, which, when EXPOSED under a NEGATIVE, DEVELOPED, FIXED, and WASHED, would produce a

LANTERN SLIDE

Frederick Evans (British, 1853–1943), Kelmscott Manor, from the Thames, ca. 1896. Lantern slide, image 3.5 × 6.7 cm (13/8 × 25/8 in.). JPGM, 84.XH.1616.33. POSITIVE TRANSPARENCY. To protect the fragile finished image, the coated side was covered with a second, same-sized piece of glass (usually about 3½ by 3½ inches [8.3 by 8.3 cm]), and their edges were taped together. Lantern slides were used both for home entertainment and for the illustration of public lectures, often of an edifying nature.

LATENT IMAGE

The *latent image* consists of a slight chemical change that has occurred in LIGHT-SENSITIVE materials such as SILVER SALTS during their EXPOSURE to light. A latent image is not yet visible, so DEVELOPMENT is necessary to reveal a visible image. In photography, the only techniques that are not dependent on a latent image are the BICHROMATE and the PRINTING-OUT processes.

LENS

Made of glass or plastic, a *lens* is the essential means by which light rays coming from an object being photographed are directed onto the NEGATIVE (or sometimes a POSITIVE) material in a CAMERA in order to produce a photograph. Light rays travel in straight lines, but when they pass from one medium (in this case, air) to another (in this case, the glass of a lens), they bend. They bend again as they emerge from the back of the lens. The front and back surface contours of a lens determine the direction in which the rays are bent. Camera lenses are shaped so that the light rays converge on LIGHT-SENSITIVE material, where the image is recorded. Modern camera lenses are not single pieces of glass but assemblies of multiple glass elements that collectively produce a clear, distortion-free image. The quality of a lens depends on the precision of its design and manufacture. Among the many kinds manufactured for use in cameras are wide-angle, telephoto, soft-focus, enlarging, and zoom lenses. High-quality lenses are also necessary in the process of Enlarging to create sharp and high contrast prints.

LETTERPRESS HALFTONE

This PHOTOMECHANICAL process was adapted from the traditional letterpress printing technique used for printing characters (such as letters and numbers). The printer's ink adheres to raised areas of the printing plate and is transferred to paper under pressure during printing. In the mid-1880s, letterpress was adapted for printing photographic images by using a HALFTONE screen that converted the intermediate gray tones of the original image into either black or white areas.

LIGHT-SENSITIVE

Light-sensitivity is the capacity to respond to light that gives SILVER SALTS (silver halides), some IRON SALTS, and BICHROMATED colloids (such as GUM BICHROMATE) their usefulness in photography. To enable or enhance that capacity to chemically or physically change by the action of light is to sensitize a material so that a photographic image can be generated. The method of sensitizing varies by photographic

process. In analogous fashion, the electronic sensors in digital cameras and scanners are also light-sensitive (see DIGITAL IMAGING).

MAT See MOUNT.

MINIATURE CAMERA

The inexact term *miniature camera* designates a very easily portable CAMERA intended to be hand-held, having a LENS of a high standard of sharpness, employing roll film (particularly 35 mm), and thus producing a small negative that requires considerable enlargement. The term is used particularly for cameras of the Leica type introduced in 1925 by Ernst Leitz II (1871–1956); it does not refer to tiny novelty cameras or to digital cameras coupled to cell phones.

MONTAGE See COLLAGE.

MOUNT / MAT

In American parlance a *mount* is a secondary support to which a photograph is affixed, the primary support being the paper on which the photograph itself was made. A mount is normally cut from heavy paper or cardstock, preferably of good quality and acid-free. If a second sheet with an opening cut into it of the size and proportion of the photograph is hinged to the mount, the ensemble is called a *mat*. The top sheet through the window of which the image is seen is called an *overmat* in America and a *passe-partout* in England, where *mat* and *mount* are more nearly synonymous terms. For safe handling, a photograph should have both mount and mat.

To attach a photograph to its mount, modern conservators prefer to use thin hinges, like those used to put stamps in albums but made of thin Japanese tissue, affixed to an edge of the photograph with wheat-starch paste. Since the 1990s, some contemporary photographers have favored large, rigid sheets of plastic, aluminum, or aluminum-plastic composite laminate as mounts for their oversized photographs. These prints are usually adhered to their mounts with an overall double-sided adhesive film (see also LAMINATE and FACE MOUNTING).

NEGATIVE / POSITIVE

As William Henry Fox Talbot (1800–1877) discovered in the mid-1830s, when a sheet of paper carrying LIGHT-SENSITIVE SILVER SALTS is EXPOSED to light, the sheet darkens in proportion to the amount of light it receives. An image of the scene outside the camera is formed on the surface of the paper, but where an object in the actual scene is light in value, its appearance on the paper is dark, and where dark, light. It was Talbot's genius to realize that if this piece of paper, the *negative*, were placed in contact with a second sheet of similarly sensitized paper, the values on the second sheet would be returned to normal by reversal, that is, would correspond to the actual values. The second sheet is a *positive*, commonly called a PRINT. The names *negative* and *positive* were suggested by Sir John Herschel (1792–1871). Talbot

NEGATIVE / POSITIVE

David Octavius Hill (British, 1802–1870) and Robert Adamson (British, 1821–1848), Sergeant of the Ninety-second Gordon Highlanders Reading the Orders of the Day, 1846. Calotype (negative) and salt print (positive), each 14.5 \times 16.7 cm (5 11 /16 \times 7%16 in.). JPGM, 84.XM.445.18 and 84.XM.445.3.

also realized that multiple positives could be made from a single negative. From this negative-positive process, all subsequent chemical photography derives. In digital photographic processes, the traditional negative has been replaced with a digital file that is neither negative nor positive, but simply a series of numbers (see DIGITAL IMAGING and DIGITAL NEGATIVE).

Negative PrintFranz Roh (German, 1890–1965), *Selbstbe-grüssung*, ca. 1930.
Gelatin silver print, 15.4 × 19.8 cm (6½6 × 7½6 in.). JPGM, 85.XP.260.133.

NEGATIVE PRINT

In a *negative print*, the highlights and shadows are the reverse of their normal appearance: the shadows are light, the highlights are dark. Made for artistic effect, negative prints can be achieved by a number of means, including placing photographic paper normally used for prints in the camera in lieu of FILM, photographing a NEGATIVE, or printing from a POSITIVE TRANSPARENCY.

OIL-PIGMENT PRINT See BROMOIL PRINT.

OROTONE

This term refers to a photographic image made from a negative that had been printed on a GLASS PLATE coated with a GELATIN SILVER EMULSION. The back of the glass plate was then painted with gold mixed with banana oil, or with bronze powders mixed in resin to give the appearance of gold, and the work was framed. The technique was popularized by Edward Sheriff Curtis (1868–1952). (Illustration on next page.)

ORTHOCHROMATIC / PANCHROMATIC

These descriptive terms apply to photographic NEGATIVE materials that have been adjusted in their spectral SENSITIVITY to produce fuller ranges of response to the color spectrum. The light-sensitive SILVER SALTS that form photographic images respond

OROTONE

Edward Sheriff Curtis (American, 1868–1952), *The Spirit of the Past—Apsaroke*, ca. 1916, from a negative of 1908.
Orotone, 35.8 × 28 cm (14 × 11 in.). Huntington Library, Art Collections, and Botanical Gardens, San Marino.

more strongly to blue light than to the balance of the spectrum, while the human eye responds most to green light. Thus, the black-and-white rendition of tonal values of mid-nineteenth-century photographs, particularly apparent in reproductions of works of art, did not correspond to actuality. Red and yellow areas appeared too dark, blues and violets too light. To correct these deficiencies, at a later period dyes were added to Emulsions to enhance their color sensitivity. In the early 1880s an *orthochromatic* (correct color) emulsion sensitive to blue and green light, but not to red light, was available. After 1905, a *panchromatic* (all color) emulsion, sensitive to blue, green, and, to a lesser extent, red light, was produced. Further refinements followed.

PALLADIOTYPE (PALLADIUM PRINT) See PLATINUM PRINT.

PANCHROMATIC See ORTHOCHROMATIC.

PANORAMA

A panorama consists of a photograph or series of photographs that encompasses a sweeping view. When an ordinary camera and lens are used, the camera is pivoted on a tripod, and a series of exposures of slightly overlapping aspects of the same view are made. The resultant segments are then trimmed and pieced together. Wide-angle lenses or panoramic cameras can produce single-exposure panoramas. From the Daguerrean era onward, many varieties of panoramic cameras have been invented. In one kind of modern camera, the film is mounted on a curved back inside the camera, and the lens automatically turns on an axis. A continuous exposure is made onto the film through a narrow slit moving with the lens. Another camera itself rotates, and the film moves past a slit at a speed coordinated to that of the

rotation. A camera called a cyclograph was devised to photograph in a continuous band around the outside of a cylindrical object. In this instance, the object rather than the camera was made to revolve, but exposure was again through a slit.

PAPER NEGATIVES See CALOTYPE and WAXED PAPER NEGATIVE.

PHOTOGENIC DRAWING

Photogenic drawing was the name given by William Henry Fox Talbot (1800–1877) for the results of his first, cameraless photographic process and derived from experiments he had begun in 1834 but did not announce until 1839. In its simplest form, the process required a smooth, high-quality sheet of writing paper that was dried

William Henry Fox Talbot (British, 1800–1877), Plant Specimen, 1840.

PHOTOGENIC DRAWING

Specimen, 1840. Photogenic drawing negative, 18.8 \times 11.5 cm ($7\%6 \times 4\%2$ in.). JPGM, 84.XM.1002.8.

after immersion in a solution of table salt (sodium chloride). Talbot then brushed the paper with a solution of silver nitrate that combined with the sodium chloride to produce silver chloride, which is a LIGHT-SENSITIVE SILVER SALT. On top of this sheet of sensitized paper Talbot laid small objects such as leaves and lace and then exposed the paper to sunlight. Those areas of the paper where the sunlight fell darkened, while those areas that the object prevented sunlight from reaching remained light. The exposure continued until the image (in negative) was completely printed-out and thus wholly visible. Talbot prevented the paper from continuing to darken by chemically stabilizing the image, if imperfectly, with a strong solution of ordinary salt that rendered the unexposed silver salts less light-sensitive but did not fix the image.

Talbot's next step was to expose sensitized paper inside simple CAMERAS of his own design: small wooden boxes with a LENS at the end opposite the paper. The results were the first, rudimentary camera NEGATIVES. Talbot placed these negative images in sunlight on top of and in contact with a second sheet of sensitized paper until a completely formed image had printed out on the second sheet. This was a POSITIVE print, the lights and darks now corresponding to those seen by the eye. These prints were similarly stabilized by means of a strong table-salt solution or, later, potassium bromide or iodide.

As photogenic drawings were highly experimental and often only stabilized (and not fixed), their appearance varies considerably from reddish tones to the palest lemons and lilacs, depending on which chemicals Talbot used. Photogenic drawings remain very light-sensitive and may darken irreversibly if exposed to too much light, for example during an exhibition.

PHOTOGLYPHIC ENGRAVING

Photoglyphic engraving, the term coined by William Henry Fox Talbot (1800–1877) for the process of producing a printing plate from a photograph, was developed in

PHOTOGLYPHIC ENGRAVING

William Henry
Fox Talbot (British,
1800–1877), *The New Louvre, Paris*, 1858.
Photoglyphic engraving
from a negative
attributed to A. Clouzard
(French, active 1854–1859)
and Charles Soulier
(French, 1840–1875),
5.5 × 7 cm (2½ × 2¾ in.).
JPGM, 84.XM.478.13.

1852, and an improved technique was patented in 1858. It depends on the principle that gelatin sensitized with potassium BICHROMATE is rendered insoluble by EXPO-SURE to light in proportion to the amount of light received. After coating a steel or copper plate with bichromated gelatin, Talbot exposed the plate to light under a POSITIVE TRANSPARENCY of the image he wished to reproduce. The plate was then dusted with powdered resin, heated to melt the resinous particles onto the surface, and then immersed in a solution that simultaneously dissolved away the part of the gelatin that had not hardened and etched those same areas. After being cleaned, the plate was inked and the surface wiped clean, ink remaining in the etched cavities. Under pressure, the inked plate was printed, thus creating a reproduction of the original image. (The resin dusting functioned much as it did in the traditional aquatint printmaking process by breaking continuous tones into discontinuous tones; see HALFTONE.) Talbot sometimes also employed a gauze screen to the same end. The 1858 patent specified a process of duplicating the etched plate by pressing a slice of gutta percha, a natural material that is much like plastic, onto the plate, then giving its molded surface a hard metal surface coating using an electrotyping technique. For these processes, he coined the term photoglyph from the Greek for "carved light."

PHOTOGLYPTIE See WOODBURYTYPE.

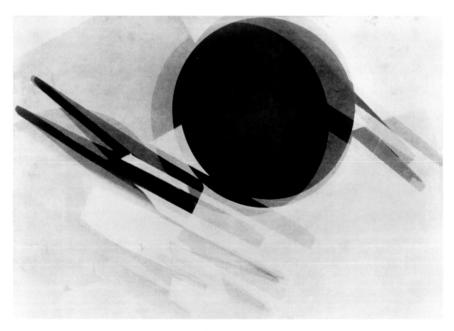

PHOTOGRAM

László Moholy-Nagy (American, b. Hungary, 1895–1946), *Photogram Number I: The Mirror*, 1922–23 (print 1928).

Gelatin silver photogram, 63.8 × 92.1 cm (251/8 × 361/4 in.). JPGM, 84.XF.450.

© Estate of László Moholy-Nagy/ARS, New York.

PHOTOGRAM

A photogram is a kind of photograph, although made without a CAMERA OF LENS. An object (or objects) is placed on top of a piece of paper or FILM coated with LIGHT-SENSITIVE materials and then the paper or film is EXPOSED to light. Where the object covers the paper, the paper remains unexposed and light in tone; where it does not cover, the paper darkens. If the object is translucent, midtones appear. After exposure, the paper is DEVELOPED and FIXED. Among the first photograms were the PHOTOGENIC DRAWINGS produced in the late 1830s by William Henry Fox Talbot (1800-1877), in which some of the objects were ferns, flowers, and pieces of lace. Other examples of photograms were made around 1918 by Christian Schad (1894–1982), who called his works Schadographs; during the 1920s and afterward by Man Ray (1890–1976), who called his Rayographs; and from the 1930s onward by Lázsló Moholy-Nagy (1884-1946).

PHOTOGRAVURE (HELIOGRAVURE)

Photogravure, also known as heliogravure, is (arguably) the finest PHOTOMECHANI-CAL means for reproducing a photograph in large EDITIONS. Although descended from the traditional printmaking process of etching and derived from Talbot's PHO-TOGLYPHIC ENGRAVING, photogravure was devised by the Austrian artist Karel Klič (1841-1926) in 1879 and further developed by him. It depends on the principle that BICHROMATED GELATIN hardens in proportion to its EXPOSURE to light. A tissue coated on one side with gelatin sensitized with potassium bichromate was exposed to light under a transparent Positive that had been Contact printed from the NEGATIVE of the image to be reproduced. The exposed tissue was wetted, then firmly pressed, gelatin-side down, onto a copper printing plate that had been prepared with a thin, uniform dusting of resinous powder. In warm water, the tissue backing was peeled away and those areas of the gelatin that had not been exposed to light were washed away. The copper plate with its remaining unevenly distributed gelatin coating was then placed in an etching bath, where some areas of the surface

PHOTOGRAVURE Charles Nègre (French, 1820-1880), Kneeling Mason, 1854. Photogravure, 5.7 × 5 cm $(2\frac{1}{4} \times 2 \text{ in.})$. JPGM, 84.XP.453.12.

of the metal were bitten away. Where the gelatin remained thick (the highlights of the print to come), the metal was eaten away slowly; where the gelatin was thin or absent, the metal was etched more quickly. Thus, corresponding to the tones of the original image, the plate was etched to different depths. When inked, the varying depths held differing amounts of ink, which were transferred to a sheet of high-quality paper by a printing press. From photogravure, Klič developed modern screen gravure (*rotogravure*), which was widely used in newspaper illustration until its replacement by offset lithography in the 1910s. If untrimmed, a finished photogravure shows the mark of the plate (the plate mark) around the image. Its blacks often resemble charcoal and its whites, if printed on good paper, stay white.

PHOTOLITHOGRAPHY

A PHOTOMECHANICAL PROCESS for printing a photographic image, *photolithography* depends, like its direct antecedent the printmaking process of lithography, on the principle that grease and water repel each other. Developed in 1855 by Alphonse-Louis Poitevin (1819–1882), the photolithographic process begins when a flat stone (*lithos* in Greek), usually limestone, or a metal plate of zinc or aluminum is coated with Gelatin (or, originally, Albumen) that has been sensitized with potassium bichromate. When exposed to light under a photographic negative, the bichromated gelatin is rendered insoluble to water in proportion to the light received. The

PHOTOLITHOGRAPHY

Alphonse-Louis Poitevin (French, 1819–1882), Man with Garden Implements, 1855. Photolithograph, 20.8 × 27.1 cm (83/16 × 105/8 in.). JPGM, 84.XP.259.6. soluble portions of the gelatin are cleaned from the limestone, which is then dampened and inked. The greasy printer's ink adheres to the areas of hardened gelatin (the darks in the finished image) but is repulsed by the areas of moist stone that do not have a hardened gelatin coating. The stone is then pressed against a sheet of paper, to which the ink is transferred, producing a reproduction of the original image. The delicate and flat finished photolithograph may show the impress of the stone, but no plate mark is visible.

PHOTOMECHANICAL PROCESSES

This group of processes includes all those techniques in which mechanical means (such as a printer's press) are used to produce HALFTONE reproductions of an originally photographic image, often in large numbers for postcards, books, or illustrated magazines. These processes include COLLOTYPE, PHOTOGRAVURE, PHOTOLITHOGRAPHY, and LETTERPRESS HALFTONE. The only *photomechanical process* that could print continuous tones was the WOODBURYTYPE.

PHOTOTHERMOGRAPHIC TRANSFER PRINT

Produced by a digital print process, *photothermographic transfer prints* have a continuous tone and a wide range of colors and are, to the casual observer, indistinguishable from Chromogenic prints on resin-coated paper or from dye diffusion thermal transfer prints. Photothermographic transfer prints have been used mainly in photographic and graphic applications since 1987. The process is proprietary to Fuji Photo Film Co. Ltd. and is marketed under the brand name Pictrography.

As is apparent from the name of the process, photothermographic transfer relies in part on the thermal development of light-sensitive materials. As such, it belongs to a wide range of processes that contain SILVER SALTS, but that use heat instead of wet chemical processing to transform the LATENT IMAGE into a visible one. Since the dyes diffuse from one material into another, this process also has similarities to the INSTANT PRINT technology.

A sheet with a three-layer emulsion acts as a negative and is exposed pixel by pixel and line by line within the printer by computer-controlled laser diodes. The sheet is then brought into contact with a receptor sheet, and the sandwich is heated and slightly moistened. During thermal development of the latent image, yellow, magenta, and cyan dyes diffuse into the surface layer of the receptor sheet and are bound into the coating. Finally, the donor sheet is peeled from the surface of the receptor sheet, resulting in a full-color image.

PIEZO PRINT (PIEZO PIGMENT PRINT)

Although often used to designate an INKJET PRINT that has been created on a device other than an IRIS printer, the terms *piezo print* and *piezo pigment print* are not generally used by museums or conservators, who prefer the simpler and more generic *inkjet print*.

PIGMENT PROCESSES

Pigment processes are any of the various photographic processes that evolved from the 1850s onward in which the final image on the paper is rendered in pigment rather than in the metals silver, iron, platinum, or palladium. They include the BROMOIL, CARBON, CARBRO, and GUM BICHROMATE processes. All depend on the principle that a colloid, such as gum arabic or GELATIN, which has been made sensitive to light by the addition of potassium BICHROMATE or the like, hardens on exposure to light in proportion to the amount of light received and so becomes insoluble in water. Pigment processes were popular because of their permanency, their wide range of possible colors, their resemblance to traditional artistic media such as etching, crayon, charcoal drawing, and watercolor, and the way the image could be altered by handwork on the surface.

PIGMENT
PROCESSES
Edward Steichen
(American, 1878—
1973), Self-Portrait
with Brush and
Palette, 1901.
Gum bichromate
print, 21 × 15.8 cm
(81/4 × 61/4 in.).
JPGM, 85.XM.261.

PINHOLE CAMERA
Ruth Thorne-Thomsen
(American, b. 1943),
Head with Ladders
from the series
Expeditions, 1979.
Gelatin silver print
from a negative made
in a pinhole camera,
9.3 × 10.8 cm (3⁵/8
× 4¹/4 in.). JPGM,
84.XP.447.13. © Ruth

Thorne-Thomsen

PINHOLE CAMERA

The most elemental form of CAMERA capable of producing a permanent image, the *pinhole camera* consists of a closed lightproof box with a pinhole opening on one surface. Through the pinhole, light projects an inverted image of the subject onto a flat, LIGHT-SENSITIVE material that has been placed on an internal surface opposite the opening. (It is, thus, a miniaturized CAMERA OBSCURA.) As only a little light enters through the minuscule opening, the receptive photographic material must be EXPOSED for a long time. The images made from pinhole cameras, not having been focused through a LENS, have soft overall definition rather than crisp detail.

PLATE: MAMMOTH, FULL, HALF, QUARTER, SIXTH

During the 1840s and later, silver-plated copper plates for making DAGUERREOTYPES were produced commercially. The largest size ordinarily available, from which the others were derived, was the *full plate* (or *whole plate*), measuring 6½ by 8½ inches (16.5 by 21.6 cm). Next was the *half plate*, 4¼ by 5½ inches (10.8 by 14 cm). The most common size, the *quarter plate*, was 3¼ by 4¼ inches (8.3 by 10.8 cm), and the *sixth* plate, sometimes called the *medium plate*, was 2¾ by 3¼ inches (7 by 8.3 cm). *Ninth* and *sixteenth* plates were much less frequently used. When GLASS PLATES for NEGATIVE materials came into use, a parallel nomenclature developed, with a *full plate* measuring 8 by 10 inches (20.3 by 25.4 cm) and a *quarter plate*, 4 by 5 inches (10.2 by 12.7 cm). *Mammoth plates* are plates of large dimensions (and considerable weight), typically 18 by 22 inches (45.7 by 55.8 cm), often used for photographing landscapes during the nineteenth century.

PLATINUM PRINT (PLATINOTYPE) / PALLADIUM PRINT (PALLADIOTYPE)

The *platinum print* process was invented in 1873 by William Willis (1841–1923), who continually refined it until 1878, when commercially prepared platinum papers became available through a company he founded. The process depends on the light SENSITIVITY of IRON SALTS. A sheet of paper, sensitized with a solution of potassium

PALLADIUM PRINT

Edward Weston (American, 1886–1958), *Armco Steel, Armco, Pipes and Stacks*, 1922.
Palladium print, 24.3 × 19.4 cm (9%6 × 7%8 in.). JPGM, 86.XM.710.7. © 1981 Arizona Board of Regents,
Center for Creative Photography.

chloro-platinate and ferric oxalate and then dried, was contact printed under a negative in daylight (or another strong source of ultraviolet light) until a faint image was produced by the reaction of the light with the iron salt (the reduction of ferric oxalate to ferrous oxalate). The paper was developed by immersion in a solution of potassium oxalate, which dissolved out the ferrous salts and reduced the chloro-platinate salt to metallic platinum in those areas where the iron salts had been exposed. An image in metallic platinum replaced one in iron. The paper was immersed in a series of weak hydrochloric or citric acid baths to remove remaining ferric salts and any yellow stains that had been formed in the earlier steps. Finally, the print was washed in water.

A variant means of development involved coating the paper with differing thicknesses of glycerin, which retarded the action of the developer that was then brushed on. Selective development followed in proportion to the glycerin thicknesses, producing varieties of intensity and tone. Platinum prints could be altered in tone by changing the temperature or composition of the developer or, after development, by immersing the print in TONING solutions containing mercuric chloride or lead acetate or uranium nitrate or gold chloride. Olive greens, reds, and blues were all possible, although grays were more usual.

Platinum prints were popular until the 1920s, when the price of platinum rose so steeply as to make them prohibitively expensive. They were in part replaced by the somewhat cheaper *palladium prints*, the process for which was very nearly the same but which employed a compound of the metal palladium rather than platinum. Both processes were valued for their great range of subtle tonal variations, usually silvery grays, and their permanence. Both have the matte texture of whatever paper was used. Recently, platinum prints have enjoyed a modest revival.

POSITIVE See NEGATIVE.

PRINT: LATER, MODERN, POSTHUMOUS, VINTAGE, COPY

Because a photographic *print* made close to the date of its NEGATIVE, by or under the direct supervision of the photographer, is thought to most clearly capture the photographer's original inspiration, it is usually the most sought-after print of any from that negative. In commerce, such photographs are often called *vintage* prints. A *modern* or *later* print is made from the original negative, presumably by the photographer, but at a later date than that of the negative and perhaps employing different printing papers from those of earlier prints. Absent an explicit statement that the photographer preferred them to earlier ones, later prints are invariably less valuable than vintage prints. A *posthumous* print is a print made from an original negative after the death of the photographer. A *copy* print is made from a new negative taken of an original print and usually has negligible value as a collectible object, except, perhaps, when the photographer uses the copying process for an aesthetic purpose.

PRINTING-OUT PAPER

Unknown maker (American, active 1890s), [Men with horse-drawn fire engines of Ladder Company No. 11 and Fire Company No. 21], ca. 1890. Gelatin silver print on printing-out paper, mounted to card, 16.4 × 20.6 cm (6⁷/₁₆ × 8 ½ in.). JPGM, 84.XD.879.96.

PRINTING-OUT PAPER

Printing-out paper was designed for the production of a photographic print from a NEGATIVE by the action of light alone on LIGHT-SENSI-TIVE material, rather than by DEVELOPMENT using chemicals (see DEVELOPING-OUT PAPER). Although SALT PRINTS and ALBUMEN PRINTS were printed out, the term printing-out paper (P.O.P.) is generally reserved for those commercially manufactured papers coated with silver chloride EMULSIONS, usually made of GELATIN but sometimes of COLLODION, that were in general use, particularly for portraiture, from the 1880s until the late 1920s. The paper was EXPOSED to daylight in CONTACT with a negative until the image was wholly visible. No chemical development followed, simply TON-ING, FIXING, and WASHING. After 1900, these papers gradually gave way to developing-out paper. As the printing-out process was slow, dependent on the weather and the time of day,

An example of the sharp detail that could be achieved with printing-out paper.

and required longer use of the negative, fewer prints could be produced in a day than with the developing-out process, in which exposure was comparatively short and could be carried out with artificial light in a DARKROOM. Photographs made on printing-out paper exhibit warm image tones and can have a wide variety of surfaces, from glossy to matte.

PROOF

A term sometimes used in photography to designate a print made from a NEGATIVE or POSITIVE. In traditional fine art printing, an *artist's proof* is the final print that the artist is satisfied with and that is consulted for quality control during the production of an EDITION. In the commercial printing industry, a proof is a trial print made for checking the colors and registration of an image before the whole edition of a book, magazine, or other printed product is produced in high volume on a press.

RC PAPER See RESIN-COATED PAPER.

RECTO / VERSO

The *recto* of a photograph is the side bearing the image, its front, as opposed to the *verso*, the back. If the photograph is mounted to another sheet of paper or other support, the verso is the back of the MOUNT.

RESIN-COATED (RC) PAPER

Resin-coated paper supports have been used as photographic print materials since the early 1970s. They are typically used for Chromogenic prints and sometimes for Gelatin silver prints, but have also been used extensively for inkjet and other digital print processes since the late 1980s. RC paper is essentially composed of a sheet of high-quality paper that has been sealed on both sides with polyethylene (PE), from which its alternate name, PE paper, is derived. The top PE layer is pigmented with white titanium dioxide particles that give the support a white base; the layer on the back is clear. The emulsion (or other type of imaging layer) is coated onto the surface of the top PE layer. Different surface textures, ranging from matte to high gloss, are found on RC papers.

RETOUCHING

The careful manual alteration of the appearance of a print or negative is called *retouching*. It is most often used in portraiture to make cosmetic improvements to a sitter's appearance, such as removing minor facial blemishes, softening outlines or wrinkles, or "powdering" shiny noses. It can also be a far more extensive correction of perceived defects in the print. Intrusive backgrounds can be muted or removed, as can extraneous compositional details. Values can be strengthened or weakened or elements added, as when clouds were painted into nineteenth-century landscapes with overexposed skies. The common tools for retouching are scalpels, perfectly pointed brushes, airbrushes, and retouching pencils. The materials are watercolors,

inks, retouching dyes, lacquers, and chemical reducers, akin to bleaches. Many of these techniques have been subsumed by the use of Photoshop and similar software. See also SPOTTING

SABATTIER EFFECT See SOLARIZATION.

SALT PRINT (SALTED-PAPER PRINT)

Salt prints, the earliest Positive prints, were normally made by Contact Printing, usually from paper negatives (Calotypes of Waxed Paper Negatives) but occasionally from Collodion negatives on Glass Plates. Invented in 1840 by William Henry Fox Talbot (1800–1877), salt prints were a direct outgrowth of his earlier Photogenic drawing process. Salt prints were made until about 1860, although in decreasing numbers after the advent of the Albumen Print in 1851.

A salt print was made by immersing a sheet of paper in a solution of salt (primarily sodium chloride) and then sensitizing it by coating it on one side with silver nitrate. Light-sensitive silver chloride was thus formed in the paper. After drying, the paper was placed sensitive-side up directly beneath a negative under a sheet of glass in a printing frame. This paper-negative-glass sandwich was exposed, glass-side up, outdoors to sunlight; that is, it was contact printed. The length of exposure, which ranged from minutes to hours, was determined by visual inspection; this was possible because the image printed-out, that is, it darkened progressively during its exposure to light. When the print had reached the desired intensity, it was removed from the frame, washed in running water, and fixed with sodium thiosulfate, at that time called hyposulfite of soda ("hypo"), which removed the unexposed silver salts, thereby rendering the paper insensitive to light. It was then thoroughly washed and dried. The print could be toned with gold chloride for greater permanence and richer tone, although, for best results, it was toned before it was fixed.

A finished salt print is often subdued in tone and reddish brown in color, and it has no surface gloss. (Variations in the process included adding GELATIN or arrow-root starch to the initial salting bath—this modified the gloss and color of the final print.) If toned, a salt print is purplish brown; if faded, yellowish brown. Its highlights are usually as white as its paper support. Occasionally salt prints were varnished with a thin coating of ALBUMEN to produce a somewhat glossy surface. Such prints have been referred to as albumenized salt prints.

It was also possible, as Louis-Desiré Blanquart-Evrard (1802–1872) announced in 1851, to make a salt print by a quicker method than printing it out. The print could be briefly exposed under the negative and Developed-Out in the same way as a negative, then fixed and washed. This method, which is less dependent than contact printing on continuous strong natural light, allowed for the making of many prints from a single negative within a single day. It produced a salt print that was more neutral in color, that is, black, gray, and white, sometimes with bluish gray undertones.

SALT PRINT (SALTED-PAPER PRINT)

William Henry Fox Talbot (British, 1800–1877), Carriages and Parisian Town Houses, 1843. Salt print with untrimmed edges from a paper negative (calotype); image 16.8×17.3 cm $(6\% \times 6^{13}\% \text{6 in.})$; sheet 19×23 cm $(7\frac{1}{2} \times 9\frac{1}{6} \text{in.})$. JPGM, 84.XM.478.6.

SCREEN PLATE PROCESSES

This term is used for a number of color transparency processes used after the turn of the twentieth century that rendered positive color images by means of a form of color screen superimposed over a Gelatin silver emulsion on a Glass plate. See autochrome

SENSITIVITY See LIGHT-SENSITIVE.

SHUTTER See EXPOSURE.

SILVER BROMIDE PRINT / SILVER CHLORIDE PRINT

See GELATIN SILVER PRINT and SILVER SALTS.

SILVER DYE BLEACH PRINT See DYE DESTRUCTION PRINT.

SILVER HALIDE See SILVER SALTS.

SILVER PRINT

Silver print is a shorthand term for what should be called a GELATIN SILVER PRINT, meaning a paper coated with a GELATIN EMULSION containing SILVER SALTS. The term should be avoided because most traditional black-and-white photographic prints contain silver, and the term is therefore too inclusive to be useful.

SILVER SALTS

Silver salts are chemical compounds formed by the combination of silver with chlorine, bromine, or iodine, collectively called the halogens, to form silver chloride, silver bromide, or silver iodide. These three silver halides are crystalline in form and are LIGHT-SENSITIVE; that is, they react to light by darkening. Each halide reacts at a different speed. These salts, alone or in combination, when coated on paper or FILM can be placed in a CAMERA and, when exposed to light directed to the paper by a LENS, produce a photographic image, most often a NEGATIVE. They are also present in the materials from which positives, for example prints, are made. The means by which the halides are formed or the way they are attached to the film or paper varies with each of the photographic processes. (See, among others, ALBUMEN PRINT, CALOTYPE, CHROMOGENIC PRINT, COLLODION, DIRECT-POSITIVE PRINT, DYE DESTRUCTION PRINT, GELATIN SILVER PRINT, and SALT PRINT.) In processing, the silver halides are converted by chemical means to metallic silver. Silver salts are thus the basis of most photographic chemistry.

SLIDE See TRANSPARENCY.

SNAPSHOT

(3⁷/₈ × 4³/₄ in.). JPGM, 84.XA.1537.36.

SNAPSHOT

A *snapshot* is an informal and apparently unposed and instantaneous photograph, usually made by an amateur, without artistic intention and as a keepsake of persons, places, or events.

SOLARIZATION / SABATTIER EFFECT

Although the term *solarization* has been used to describe the Sabattier effect, the partial reversals of tone in photographic prints to which both terms refer have different causes. True *solarization* occurs when an intense light source, such as the sun, is visible in a photograph that has been overexposed in the CAMERA, usually accidentally. Overexposure causes the light source to appear dark in the print. The sun becomes a black disk, but the reversal of tones is limited to this area of the print.

The Sabattier effect, named for Armand Sabattier (1834–1910), who described it in 1862, is the result of an intentional darkroom technique, used to produce tone reversals. The procedure is to partially develop a negative or print, momentarily expose it to light, then continue the normal development process. Areas in negatives that are clear (and will therefore print dark in the positive print) become relatively dense due to the intermediate exposure and therefore print as white in the positive, which is observed as a tone reversal that principally occurs in the shadows in the completed prints. At boundaries between areas of the image where reversal has occurred and where it has not, a distinct black line is visible in the print if it was the negative rather than the print that was flashed with light; if the print was exposed, the line will be white. Results of the Sabattier effect are somewhat unpredictable.

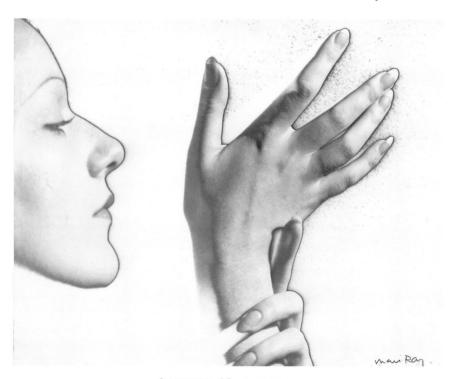

SOLARIZATION / SABATTIER EFFECT

Man Ray (American, 1890–1976), *Profile and Hands*, 1932. Gelatin silver print showing Sabattier effect, 18 × 22.9 cm (7½6 × 9 in.). JPGM, 84.XM.839.5. © Man Ray Trust/ARS-ADAGP.

SPIRIT PHOTOGRAPH
William H. Mumler
(American, 1832–1884),
John J. Glover with
Spirit of Old Woman
Hovering above Him,
ca. 1862. Albumen
print carte-de-visite,
9.6 × 5.7 cm
(3³/₄ × 2¹/₄ in.).
IPGM, 84.XD.760.1.6.

SPIRIT PHOTOGRAPH

In the nineteenth century, a ghostly figure was sometimes included alongside or above the sitter in a portrait in order to convey the impression that a spirit was present. *Spirit photographs* were usually made by having the person playing the spirit remain in view only briefly during the long exposure of a negative. The hoax being perpetrated in a spirit photograph was that photography could capture images of the dead or departed, particularly if the sitter thought about the absent person. See also GHOST.

SPOTTING

Spotting is a specialized kind of RETOUCHING used to fill accidental pinholes in a NEGATIVE or, more often, to darken minute white spots on a print, often caused by dust on the negative. When a photograph has FADED, the spotting sometimes remains darker, giving an idea of the image's original tonality and color.

STEREOGRAPH

A stereograph is a pair of photographic images that are arranged side by side on a single support and, when viewed through a stereoscope designed to hold it, gives the appearance of a single image having three dimensions. A standard stereograph consists of a piece of stiff card MOUNT, often highly colored, usually between 3½ and 4½ inches (8.9 to 11.4 cm) tall and about 7 inches (17.8 cm) wide, to which

STEREOGRAPH

Edward and Henry T. Anthony (American, 1818–1888 and 1814–1884). Sailing down the Bay, 1869. Albumen print stereograph, recto and verso; image: 7.4×15.4 cm ($2^{15}/6 \times 6^{1}/6$ in.). JPGM, 84.XC.873.3309.

two photographs, generally ALBUMEN or GELATIN SILVER PRINTS, each between 3 and 4½ inches (7.6 to 11.4 cm) high and about 3 inches (7.6 cm) wide, have been mounted next to each other. Remaining space on the front of the card usually bears the photographer's and/or publisher's name(s) and a title, as does the back of the card. The two photographs are not identical but exhibit a slight lateral shift, having been made with a dual-lens CAMERA, the centers of the LENSES being set at the same average distance apart (2½ inches [6.3 cm]) as the centers of a pair of human eyes. Each photograph is thus an image of what one eye would see. When viewed through the stereoscope, the two images combine, approximating human binocular vision. In order to convey the illusion of depth in the depicted image, a strong foreground is desirable. Viewing stereographs was a vastly popular parlor amusement from the mid-1850s well into the twentieth century. Stereographic subjects vary widely, although topographical views are perhaps most common.

TALBOTYPE See CALOTYPE.

TINTED PHOTOGRAPH

A *tinted photograph* has a single overall color resulting from the addition of dyes to the photographic materials by a commercial manufacturer. The color is suffused throughout the EMULSION OF BINDER and is most visible in the highlights and midtones. Albumen printing papers in pale pink or blue were available from the 1870s onward, as were Gelatin Silver printing-out papers in pale mauve or pink from the 1890s onward. Other kinds of tinted papers also existed. Such coloration is now often very faded, since the dyes are commonly quite sensitive to light. Tinted photographs are to be distinguished from toned of hand-colored photographs, in which the image itself, and particularly its foreground elements, are colored by the individual photographer's manipulations.

Tinted Photograph Antonio Beato (British, b. Corfu, ca. 1825 ca. 1903), [Colossi of Memnon], ca. 1885. Rose-tinted albumen print, 35.8×26.2 cm $(14\frac{1}{8} \times 10\frac{5}{6}$ in.). JPGM, 84.XM.1382.65.

TINTYPE (FERROTYPE)
Unknown American
maker, *Boy with Tricycle*,
ca. 1870. Ferrotype, in
its folder, 7.6 × 4.5 cm
(3 × 1³4 in.). JPGM,
84.XT.1395.78.

TINTYPE (FERROTYPE)

The ferrotype, better known as the tintype in America, where it reached its greatest popularity, was derived from the AMBROTYPE and, like it, depended on the fact that a COLLODION NEGATIVE appeared to be a POSITIVE image when viewed against a dark background. In the case of the tintype, the negative was made not on GLASS but on a thin sheet of iron coated with an opaque black or chocolate brown lacquer or enamel. (As the tintype was made from iron rather than tin, tintype is a misnomer.) The lacquered sheet, which was commercially available, was coated with WET COLLODION containing SILVER SALTS just before EXPOSURE in the camera. DEVELOP-MENT immediately followed exposure. Later refinements led to the use of a DRY COLLODION-coated metal plate. As the finished image was in fact, although not in appearance, a negative, the image was usually laterally reversed. A tintype was a unique image and could be duplicated only by being rephotographed. Despite the image reversal, tintypes were almost always used for portraiture. From their origin in the 1850s until the end of the century and beyond, they remained popular because they were very inexpensive. They were often made and sold by street vendors. Like DAGUERREOTYPES or AMBROTYPES, tintypes were sometimes placed in small folding cases (see CASED PHOTOGRAPHS), but more often they were inserted into simple folding cards or window mats, sometimes made of thin metal. Most tintypes have very limited tonal ranges and appear flat and soft by comparison with either a daguerreotype or an ambrotype.

TONING

Toning denotes a variety of means available for changing or shifting the color of the image of a photographic print. Its use is largely governed by aesthetic choice on the part of the photographer, but toning with certain compounds, notably gold chloride, selenium, sulfur, or platinum salts, also enhances the stability of the image (and thus the permanence of the print) and usually increases contrast. Gold toning, the most common means in the nineteenth century, originated in the Daguerrean era (see DAGUERREOTYPE), and since then each photographic process has had specific toning procedures to produce specific hues. Selenium toning prevails today. Toning occurs in the course of chemical processing, before FIXING (for PRINTING-OUT PAPERS) or after DEVELOPMENT in subsidiary steps in which the silver comprising the image is chemically altered or partially replaced by another metal. The number of variables in any of these procedures is large. The original chemical composition of the print, the temperature, composition, and strength of the chemical solutions, the duration of processing, and the means of drying the print all affect the final tone. In postdevelopment toning, in which the silver is altered, bleached, or replaced, the choice of toning solutions is wide, including those containing sulfur or, most frequently, one of the following metals: gold, iron, copper, uranium, mercury, platinum, palladium, vanadium, or selenium. The range of possible tones is concomitantly wide, including warm browns, purples, sepias, blues, olives, red-browns, and blue-blacks. A toned photograph should be distinguished from a TINTED or HAND-COLORED one.

TRANSPARENCY / SLIDE

Transparencies, or slides, are positive photographic images on a transparent support, typically GLASS or FILM. They are generally made for viewing with a device that shines light through them and projects the image through a LENS onto a wall or screen, thereby greatly enlarging the image. Sometimes light tables are used to view transparencies. Black-and-white transparencies were traditionally called LANTERN SLIDES. The first practical color transparencies were screen plate materials such as autochromes. In 1935, the first chromogenic transparency films were introduced (Kodachrome), and many variations of chromogenic positive films have been produced since then. Slides are most commonly found on roll film that is either 35 mm or 2½ inches wide, although sheet film in various formats has also been popular, especially in professional photography. For their protection, individual slides are commonly placed in plastic, metal, or cardboard mounts, which enable them to be easily handled and used in a slide projector. Because of PowerPoint and similar computer programs, slides are rapidly becoming obsolete.

VAN DYKE PRINT See KALLITYPE.

VARIANT

Ralston Crawford (American, 1906–1978), *Barbershop, New Orleans*, 1960. Gelatin silver print, 60.7 × 51 cm (24½ × 20½ in.). Jpgm, 84.xm.151.158. *Pete and Jack's Barbershop*, 1960. Gelatin silver print, 24.7 × 19.8 cm (9¾ × 7¹³/16 in.). Jpgm, 84.xm.151.121. © Ralston Crawford Estate.

VARIANT

A *variant* is an image that is closely related to, but not the same as, a known image, as when a photographer makes a second, horizontal, photograph of a still life that was first photographed in a vertical format, without significantly changing lighting or exposure and, presumably, during the same studio session. A variant may also occur when a photographer prints the same negative twice but chooses to alter tonalities or contrast significantly. (With modern CAMERAS, roll FILM, frequent exposures, and especially digital cameras, the potential for variants has multiplied, but the photographer must choose to print two versions of an image to create an actual variant.)

VERSO See RECTO.

VIEW CAMERA (FIELD CAMERA)

The imprecise American term *view camera* is roughly equivalent to the British term *field camera* and is applied to CAMERAS meant for making relatively large-scale NEGATIVES, particularly of outdoor scenes. It often refers to nineteenth-century cameras that required tripods and used GLASS PLATES that were necessarily EXPOSED one at a time and CONTACT PRINTED rather than ENLARGED. View cameras have a variety of means for altering the angle of the LENS in relation to that of the negative. Since the twentieth century, such cameras have often been used for architectural studies, for advertising and commercial work in studios, and sometimes for work in the field. A view camera is the opposite of a MINIATURE CAMERA.

VIGNETTE

Bayard & Bertall (French [Hippolyte Bayard, 1801–1887, and vicomte Charles Albert d'Arnoux, 1820–1882]), [*Unidentified man*], ca. 1863. Albumen print vignetted in the negative, mounted to a carte-de-visite, 7.3 × 5.1 cm (2⁷/8 × 2 in.). JPGM, 84.XD,1157.1386.

Felice Beato (British, b. Corfu, 1825–ca. 1908), [Aristocratic young lady], ca. 1863–68. Albumen print vignetted in the printing process, 23.8 × 17.6 cm (9³/8 × 6¹⁵/16 in.). Partial gift from the Wilson Centre for Photography. Jpgm, 2007.26.170.

VIGNETTE

A *vignette* is a photograph in which a central image dissolves into a surrounding ground, nearly always a field of white. Oval vignetting was popular in nineteenth-century portraiture and was accomplished by photographing the subject through an opaque mask with an oval opening placed close to the LENS or, more frequently, by printing the NEGATIVE through a similar mask with partially translucent inner edges. (The term is sometimes ill-advisedly used to describe the unintentional effect in nineteenth-century photographs created when an image falls off at its corners because the image projected by the lens onto the negative did not cover its whole area; unexposed areas at the corners appeared black. The term is more appropriate if the effect was intentional.)

WASHING

At various stages of the photographic processes, principally after fixing, or as part of toning, thorough *washing* in running water of photographic materials such as negatives or prints is required to remove excess chemicals that will cause later determination such as discoloration or fading. Other chemicals may be added to the water to increase the solubility of the excess processing chemicals. The instability of photographs made before 1850 may largely be attributed to insufficient washing or impurities in the water used.

WAXED PAPER NEGATIVE

Announced in 1851 by its inventor, Gustave Le Gray (1820–1884), the *waxed paper* process improved the translucency of the CALOTYPE negative. Le Gray rubbed wax into the paper NEGATIVE *before* SENSITIZING it in a silver nitrate bath and EXPOSING it in the camera. As the wax rendered the body of the paper more transparent by filling the interstices between the paper fibers, greater clarity of detail was achieved in the negative, which translated to shorter exposure times and better rendition of details in the resultant print, whether SALT or ALBUMEN. Before this innovation, photographers had sometimes waxed their paper negatives, but only *after* developing them when preparing to print. As Le Gray's paper could be prepared several days before use and did not require immediate Development, it was particularly useful for traveling photographers, some of whom preferred it even after the advent of Collodion negatives on Glass. (Le Gray's process also differed from Talbot's CALOTYPE process in the means used to sensitize the paper.)

WET COLLODION See COLLODION.

WETSTAMP

Wetstamp on the verso of a photograph by Martin Munkácsi (American, b. Hungary, 1896–1963), 2.5 × 4.4 cm (1 × 1³/₄ in.). JPGM, 84.XP.727.10.

Aufnahme: Martin Munkácsi Berlin-Schöneberg Erfurter Str. 9 Copyright vorbehalten

WETSTAMP

A *wetstamp* is an identifying mark made by a photographer, collector, distributor, publisher, or institution by pressing an inked stamp onto a photograph, RECTO or VERSO, in order to assert authorship, ownership, or copyright. Wetstamps are occasionally useful in determining provenance.

WOODBURYTYPE (PHOTOGLYPTIE)

The *Woodburytype*, a type of Photomechanical reproduction of a photograph, was patented in 1864 by Walter Bentley Woodbury (1834–1885). Despite the painstaking care required for its production, it remained popular until about 1900 because of the

WOODBURYTYPE

John Thomson (British, 1837–1921). *Covent Garden Flower Women*, 1877. Woodburytype, 11.1 × 8.5 cm (4% 6 × 3% in.). JPGM, 84.XB.1361.3.

very high quality of the final image. This image was formed in pigmented GELATIN and, in Woodbury's words, depended on the principle that "layers of any semitransparent material seen against a light ground produce different degrees of light and shade, according to their thickness." Woodbury poured a coating of COLLODION onto a sheet of glass thoroughly dusted with talc. When the collodion had dried, the glass was recoated with a solution of BICHROMATED gelatin that hardens in proportion to its EXPOSURE to light. This collodion-gelatin film was stripped from the glass and exposed in CONTACT under a NEGATIVE of the image to be reproduced. (The talc undercoating facilitated the separation of the film from the glass.) The portion of the gelatin that had not hardened was then WASHED away, and the film left to dry. The resultant hard gelatin had formed a three-dimensional relief that was squeezed under very high pressure onto a sheet of soft lead, producing a reversal mold that could be used for printing. After being greased, the lead mold was filled with pigmented gelatin, usually a rich purple-brown in color, and a sheet of paper was placed on it. In a hand press, the gelatin was forcibly transferred to the paper, the excess gelatin being forced out around the edges of the mold. Once the paper was removed from the press, the gelatin contracted and flattened slightly as it dried. The inky edges were TRIMMED away and the print MOUNTED. The tonal scale of the resultant image in pigmented gelatin was very true to the original, and the image was highly luminous. Unlike images produced by other photomechanical processes, a Woodburytype, called une photoglyptie by the French, has continuous tone, showing neither a screen nor a grain pattern. Woodburytypes are usually labeled as such.

Selected Bibliography

The bibliography that follows is confined to a few twentieth- and twenty-first-century works that are particularly helpful and generally available in reference libraries. It does not include the nineteenth- and early twentieth-century manuals that were extensively consulted in the writing of this book.

Technical

Cartier-Bresson, Anne, ed. *La Vocabulaire technique de la photographie.* Paris: Éditions Marval, Paris Musées, 2007.

Coe, Brian, and Mark Haworth-Booth. A Guide to Early Photographic Processes. London: Hurtwood Press, 1983.

Crawford, William. The Keepers of Light: A History and Working Guide to Early Photographic Processes. Dobbs Ferry, N.Y.: Morgan and Morgan, 1979.

Focal Encyclopedia of Photography. New York: McGraw-Hill, 1969.

INTERNATIONAL CENTER of Photography. Encyclopedia of Photography. New York: Crown, 1984.

JONES, BERNARD E., ed. Cassell's Cyclopedia of Photography. 2 vols. London: Cassells, 1911.

JÜRGENS, MARTIN C. The Digital Print: Identification and Preservation. Los Angeles: Getty Conservation Institute, 2009.

KIPPHAN, HELMUT. Handbook of Print Media: Technologies and Production Methods. Berlin and New York: Springer, 2001.

LAVEDRINE, BERTRAND. A Guide to the Preventive Conservation of Photograph Collections. Los Angeles: Getty Conservation Institute, 2003.

——. (Re)connaître et conserver les photographies anciennes. Paris: Comité des travaux historiques et scientifiques, 2007.

MACAULEY, DAVID. The Way Things Work. Boston: Houghton Mifflin, 1988.

Nadeau, Luis. Encyclopedia of Printing. Photographic, and Photomechanical Processes. 2 vols. Fredericton, New Brunswick: Atelier Luis Nadeau, 1989 and 1994. eBook edition v. 1.1, 2006.

Peres, Michael R., ed. *The Concise Focal Encyclopedia of Photography: From the First Photo on Paper to the Digital Revolution*. Amsterdam: Elsevier; Burlington, Mass.: Focal Press, 2008.

REILLY, JAMES M. Care and Identification of Nineteenth-Century Photographic Prints. Rochester, N.Y.: Eastman Kodak, 1986.

ROMANO, FRANK J., ed. *Delmar's Dictionary of Digital Printing & Publishing.* Albany, N.Y.: Delmar Publishers, 1997.

STROEBEL, LESLIE, ET AL. Photographic Materials and Processes. Boston: Focal Press, 1986.

Historical

BERNARD, BRUCE, AND VALERIE LLOYD. *Photodiscovery: Masterworks of Photography, 1840–1940.* New York: Harry N. Abrams, 1980.

Goldschmidt, Lucien, and Weston Naef. The Truthful Lens: A Survey of the Photographically Illustrated Book, 1844–1914. New York: Grolier Club, 1980.

Greenough, Sarah, et al. On the Art of Fixing a Shadow: One Hundred and Fifty Years of Photography. Exh. cat. Washington, D.C.: National Gallery of Art; Chicago: Art Institute of Chicago, 1989.

Hannavy, John, ed. *The Encyclopedia of Nineteenth-Century Photography.* 2 vols. New York: Taylor and Francis Group, 2008.

Jeffrey, Ian. Revisions: An Alternative History of Photography. Bradford, UK: National Museum of Photography, Film & Television, 1999.

Naef, Weston. The Collection of Alfred Stieglitz: Fifty Pioneers of Modern Photography. New York: Metropolitan Museum of Art, 1978.

Newhall, Beaumont. *The History of Photography: From 1839 to the Present.* New York: Museum of Modern Art, 1982.

OLIVER, BARRET. A History of the Woodburytype. Nevada City, Calif.: Mautz, 2006.

ROSENBLUM, NAOMI. A World History of Photography. 3rd ed. New York: Abbeville Press, 1997.

SZARKOWSKI, JOHN. Photography Until Now. Exh. cat. New York: Museum of Modern Art, 1989.

WEAVER, MIKE, ed. The Art of Photography: 1839–1889. Exh. cat. Houston, Tex.: Museum of Fine Arts, 1989.

Index

Note: Page numbers in boldface indicate main	cropping, 24, 24 <i>f</i>
topics. Page numbers followed by the letter findicate	Cutting, James Ambrose, 1
illustrations.	cyanotype, 24–25 , 25 <i>f</i> , 57
A	D
albumen print, 1, 1 <i>f</i> , 4, 7, 14, 84	daguerreotype, 1–2, 14–16, 26–27, 26 <i>f</i> , 73
ambrotype, 1–2 , 2 <i>f</i> , 14–16, 27	dark chamber. See darkroom
aperture, 42 , $42f$	darkroom, 27
artist's proof, 77	density, 27–28 , 35
attribution, 3	depth of field, 28, 28f
autochrome, 3–4 , 3 <i>f</i>	deterioration, 24, 29–30, 29 <i>f</i> , 45, 89
autoentonie, y 4, y	developing out, 41, 78
В	developing-out paper, 30, 40, 43, 45, 77
baryta, 43, 46	development, 8–9, 27, 30, 60
Bayard, Hippolyte, 34–35	dichromate processes. See bichromate processes
bichromate processes, 4 , 45, 48–50, 68, 69–71, 91	digital enlarger, 31
binary system, 31	digital exposure to photographic material, 31, 33
binder, 4, 40	digital image, 31–32 , 32 <i>f</i>
Blanquart- Evrard, Louis-Desiré, 1	digital imaging, 31–32, 51
blindstamp, 5, 5 <i>f</i> , 55	digital negative, 33f
blueprints, 25	digital output photograph, 31
brayer, 5	digital print, 31, 33, 37, 39–40, 53–55, 56–57, 71
bromoil print, 5–6 , 6f	dimensions, 33
burning-in, 6 –7	direct-positive print, 33–34
	discoloration. See deterioration
C	dodging, 35
cabinet card, 7, 7f, 14	double-exposure, 35–36 , 35 <i>f</i>
calotype, 8–9 , 8 <i>f</i> , 10	dry collodion process, 20 , 36, 85
camera, 9, 10, 11, 48, 60, 61, 65–66, 67, 73, 87	dry plate, 36 , 40, 48
camera lucida, 10, 10f	drystamp. See blindstamp
camera obscura, 10f, 11	dye destruction print, 34, 36 , 37f
carbon print, 11-12 , 12f	dye diffusion print, 33, 55–57, 56 <i>f</i> dye diffusion thermal transfer print (D2T2), 37
carbro print, 13-14, 13 <i>f</i>	dye imbibition print. See dye transfer print
card photograph, 14	dye sublimation print. See dye diffusion thermal
carte-de-visite, 14, 15f	transfer print
cased photograph, 14–16, 15f, 27	dye transfer print, 38 , 38 <i>f</i>
cellulose acetate, 43	dye transfer print, 30, 30j
cellulose nitrate, 43	E
charge-coupled device (CCD), 31	edition, 39
chromogenic print, 16–17 , 16 <i>f</i> , 43	electrophotographic print, 33, 39–40, 39 <i>f</i>
Cibachrome, 36	emulsion, 16, 40 , 45, 55–56, 65
cliché verre, 17–18, 17 <i>f</i>	enlargement, 6–7, 30, 41 , 41 <i>f</i> , 45, 60
collage, 18–19	exposure, 4, 22–23, 31, 35–36, 42, 42 <i>f</i> , 47, 82
collodion, 4, 19–20, 19 <i>f</i> , 40	
collodion positive, 1	F
collodion printing-out paper, 20	face mounting, 43
collotype, 21–22 , 21 <i>f</i>	fading, 37, 82, 84
color-coupler print, 17	ferrotype. See tintype
color laser print, 39-40	ferrotyping, 46
combination print, 22–23 , 22f	fiber-based paper, 43 , 46
contact print, I, 23, 30, 4I, 45, 48-49	field camera. See view camera
contact sheet, 23, 23f	film, 43
copy print, 75	film recorders, 31
crackelure (crackle), 24	fixing, 1, 9, 30, 35, 43-44, 57, 67, 77

flash, 44 <i>f.</i> 45	N
foxing, 45	negative, 8–9, 22–23, 33, 43, 61–63, 62 <i>f</i> , 89
F-stops, 42	negative print, 63 , 63 <i>f</i>
full plate, 73	nonimpact prints, 33
	T
G	O
gaslight paper, 30	oil-pigment print, 5–6 , 6f
gelatin, 4, 11–12, 13, 21, 38, 40, 45, 69–70	orotone, 63, 64 <i>f</i>
gelatin silver print, 5, 45–46 , 46 <i>f</i> , 80	orthochromatic, 63-65
ghost, 47, 47f	overmat, 61
giclée, 48, 53, 57	
glass, 48	P
glass plate, 17–18, 36, 48, 52–53, 73	palladium print (palladiotype), 74–75, 74 <i>f</i>
grayscale, 32	panchromatic, 4, 63–65
ground glass, 48	panorama, 64 <i>f</i> –65 <i>f</i> , 65–66
gum bichromate print, 48–50 , 49f	paper negatives. See calotype; waxed paper negative
gun cotton, 20	passe-partout, 61
	peel-apart system, 55
Н	photogenic drawings, 66–67 , 66 <i>f</i> , 69
halation, 50 , 50 <i>f</i>	photoglyphic engraving, 67–68, 67 <i>f</i>
half plate, 2f, 73	photoglyptie. See woodburytype
halftone, 50–51 , 51 <i>f</i> , 60, 71	photogram, 68 <i>f</i> , 69
halftone, letterpress, 60	photogravure, 51, 69–70, 69f
hand-colored photograph, 2f, 52, 52f	photolithography, 21–22, 70 , 70f
heliogravure, 69 – 70	photomechanical processes, 4, 21–22, 50–51, 60, 69–70,
hologram, 52-53	70-71, 71, 90-91
I	photomontage, 19
	photothermographic transfer print, 33, 71
Ilfochrome, 36	Pictrography, 71
imaging processes, 31 inkjet print, 5, 33, 39, 48, 53–55, 54 <i>f</i> , 57, 71	piezo pigment print, 53, 71
inscription, 55 , 55 <i>f</i> , 59 <i>f</i>	piezo print, 71 pigment processes, 71, 71f. See also specific processes
instant print, 55–57 , 56f	pinhole camera, 72, 72 f
integral instant print system, 55	pixel, 31–32
Iris print, 48, 57	plates, 73
iron salts, 23, 24–25, 57, 74–75	platinum print (platinotype), 57, 74–75
	Polaroid process, 55
K	polyester film, 43
kallitype, 57–59, 58 <i>f</i>	polyethylene (PE) paper, 77
71 . 77 . 77 . 77	positive, 3-4, 33-34, 61-63 , 62 <i>f</i> , 67. See also print
L	posthumous print, 75
laminate, 59	preserved collodion, 20
lantern slide, 59–60 , 59 <i>f</i> , 86	preserver, 16
lasers, 52-53	print, 75. See also positive; specific types
latent image, 9, 30, 60	printing out, 24, 77, 78
later print, 75	printing-out paper, 21, 23, 45, 76-77, 76f, 84
lens, 42, 60, 65	proof, 77
letterpress halftone, 60	
light-sensitive, 29, 42, 60-61 , 63-65, 80	Q
lithography, 5	quarter plate, 73
Lumière, Louis, 3–4	
	R
M	RC paper. See resin-coated paper
magic lantern, 59	recto, 77
mammoth plate, 73	reflection hologram, 53
mat, 27, 61	resin-coated (RC) paper, 43, 46, 77
matrix, 5	reticulation, 21
miniature camera, 61	retouching, 32, 77-78, 82
modern print, 75	rotogravure, 70
mold, 30	
mount 5 42 50 61 77	
mount, 5, 43, 59, 61, 77	

```
Sabattier effect, 81, 81f
salted-paper print, 78, 79f
salt print, 8, 9, 78, 79f
screen plate processes, 3-4, 79, 86
sensitivity. See light-sensitive
separation negatives, 14, 38
serigraph, 48
shutter, 42, 42f, 47
silver bromide print, 13, 45-46
silver chloride print, 45-46, 76
silver dye bleach print. See dye destruction print
silver halides. See silver salts
silver print, 80
silver salts, 16, 29, 40, 43-44, 45-46, 66-67, 77, 80
single-lens reflex (SLR) cameras, 48
sixth plate, 73
slide, 59-60, 86
snapshot, 80, 80f
sodium thiosulfate, 43-44
solar enlarger, 41
solarization, 81, 81f
spirit photograph, 82, 82f
spotting, 82
starch, 4
stereograph, 82-83, 83f
Talbot, Henry Fox, 8-9, 61-63, 66-67, 67-68
talbotype. See calotype
tinted photograph, 84, 84f
tintype, 85, 85f
toner, 40
toning, 1, 5, 46, 77, 86
transfer print. See dye diffusion thermal transfer print;
  dye transfer print; photothermographic transfer print
transmission hologram, 52-53
transparency, 3-4, 34, 36, 41, 43, 59-60, 79, 86
trimming. See cropping
van Dyke print, 59
variant, 87, 87f
verso, 77
view camera, 48, 87
vignette, 88f, 89
vintage print, 75
washing, 1, 9, 30, 44, 89
waxed paper negative, 89
wet collodion process, 19-20, 19f, 85
wetstamp, 55, 90, 90f
Wollaston, William Hyde, 10
woodburytype, 90–91, 90f
```

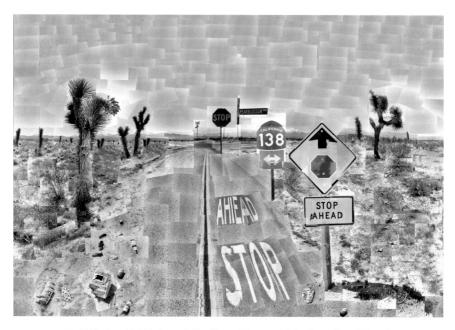

David Hockney (British, b. 1937), *Pearblossom Hwy., 11–18th April 1986 (Second Version)*. Photographic collage, 181.6 × 271.8 cm (71 ½ × 107 in.). JPGM, 97.XM.39. © David Hockney.

John Harris, Editor

Frances Bowles, Manuscript Editor

Kurt Hauser, Designer

Stacy Miyagawa, Production Coordinator

Dominique Loder, Photo Reseacher

Photography by Imaging Services at the Getty Museum

Typeset by Diane Franco